Modern Artists On Art
Ten Unabridged Essays

Edited by

Robert L. Herbert

PRENTICE HALL PRESS

New York London Toronto Sydney Tokyo

To George Wittenborn

Published in 1986 by Prentice Hall Press
A Division of Simon & Schuster, Inc.
Gulf + Western Building
One Gulf + Western Plaza
New York, NY 10023

Originally published by Prentice-Hall, Inc.
PRENTICE HALL PRESS is a trademark of Simon & Schuster, Inc.
Library of Congress Catalog Card Number: 64-7568

ISBN 0-13-586859-9
Manufactured in the United States of America

10 9 8 7 6 5 4

Preface

This book brings together essays by major painters and sculptors of the twentieth century, selected for their intrinsic quality and documentary value. They are not abridged or condensed in any manner, but presented in their entirety to permit the fullest possible expression of their authors' ideas. Another kind of anthology may choose to relinquish such completeness for an extended range of interests, and several excellent gatherings, both in print and in preparation, offer a rewarding sweep across modern art. By their nature, however, they can include only short excerpts and are apt to subordinate the individual artist to thematic or chronological schema. The essays in this collection, since they are left intact, carry the reader into deeper and more prolonged contact with the artists, one at a time. For the same reason, they may have a second and new life among those outside the visual arts who are apt to be put off by the anthology of short selections.

The choice of essays was determined quite simply. A list was established, based upon several, admittedly arbitrary criteria: widely recognized historical significance, classroom use and experience, the quality of thought and expression (which has helped determine the previous two), and a representative expression of the different modern attitudes toward art. Then as many of these were included as the tangled web of copyright permitted.

One essay, Le Corbusier and Ozenfant's *Purism,* is here given its first English translation, and four others are revised or retranslated. Mrs. Max Beckmann supplied corrections to *On My Painting* from her late husband's manuscript. My wife has retranslated Kandinsky's *Reminiscences,* and I have revised the 1913 translation of Gleizes and Metzinger's *Cubism;* I have more extensively retranslated Boccioni's *Technical Manifesto of Futurist Sculpture* and his preface to the 1913 exhibition of his sculpture in Paris, neither of which has been adequately served by existing translations.

iii

These five translations have consistently maintained the flavor of the original texts (the other essays were first published in English or else in excellent translations). Coined words have been given English equivalents whenever it is certain that the author was seeking special emphasis: in *Cubism,* for example, "intellective effort" for *effort intellectif.* Unusual punctuation and spacing is retained if it is an integral part of the original. In *Purism,* the constant use of semicolons to subordinate a series of statements to one dominant idea, and the frequent wide spacing between lines to separate one series from the next, are stylistic mannerisms which suit perfectly the essay's hard and geometric clarity. Brackets are used to enclose all editorial words or phrases, in both the texts and the footnotes; parentheses and ellipses are the authors', never the editor's.

I am most grateful to several of the artists who authorized the reprinting of their essays: Naum Gabo, Henry Moore, Amadée Ozenfant and Le Corbusier; to Mme. Albert Gleizes and Mrs. Max Beckmann for facilitating the inclusion of their late husbands' writings; to Mr. Harry Holtzman and Attorney Ralph Colin, acting for the estates of Piet Mondrian and Curt Valentin, and to Faber and Faber Limited and Paul Theobald and Company, for their authorizations. My wife postponed her own scholarly work to retranslate Kandinsky's *Reminiscences,* and had the fortitude to help prepare and proofread the manuscripts.

 R. L. H.

Contents

Gleizes & Metzinger
Cubism

Cubism, the collaborative effort of the painters Albert Gleizes
(1881-1953) and Jean Metzinger (1883-1956), has been read
less than Apollinaire's *Cubist Painters,* due to the poet's rep-
utation, the charm and wit of his essay, and its greater avail-
ability. Yet there can be no doubt that *Cubism* is a more
certain embodiment of the ideas of one large group of
Cubist painters, and a much more reasoned presentation
of artistic theory.

Gleizes and Metzinger had met in 1910, when both had
already adopted the new visual language whose initial im-
pulse came from Picasso and Braque. By the spring of 1911,
Gleizes and Metzinger banded together with Léger, Delau-
nay, and Le Fauconnier at the *Salon des Indépendants* to
form a self-aware artistic movement. Although Picasso and
Braque remained aloof, Cubism burgeoned over the next
months, with public exhibitions, many articles, and inces-
sant interchange of ideas in the studios of Puteaux and
Courbevoie. Unlike the two initiators, whose still lifes,
nudes, café and studio interiors showed no overt social
concern, the Puteaux-Courbevoie group (by now including,
among others, the brothers Jacques Villon, Marcel Du-
champ, and Raymond Duchamp-Villon) chose themes which
they considered more modern, especially the city and its
industrial suburbs. In October 1912, they joined in the
Section d'Or exhibition, one of the climactic events of pre-
war painting. Just a few weeks earlier, the essay *Cubism* had
been published.

Gleizes and Metzinger had written the essay in the span
of months preceding the *Section d'Or,* the most dynamic

period in the history of Cubism. In contrast to Picasso and Braque who, by keeping to themselves, tended to let others speak for them, the Puteaux group was anxious to explain itself. From their many interviews and articles of 1911 to 1913, we are entitled to conclude that *Cubism* embodies some of the ideas of the circle as well as those of its two artist-authors.

Published by Figuière in 1912, *Cubism* was given its first and only English translation in 1913 by the firm of T. Fisher Unwin. Their successors, Ernest Benn Limited, as far as their rights are involved, have kindly authorized me to reprint it. The 1913 translation is an excellent one, but at times a bit insensitive and lacking in nuance. I have revised it accordingly, especially in order to preserve the flavor of its coined words, and its assertive, energetic mood. I am immensely grateful to Daniel Robbins, Assistant Curator of the Solomon R. Guggenheim Museum, for his comments; his superb catalogue and exhibition of Gleizes' work (Autumn 1964) may one day be continued by an annotated, scholarly edition of *Cubism*.

Cubism

The word *Cubism* is only used here to spare the reader any doubts about the object of this study, and we hasten to state that the idea it implies, volume, could not by itself define a movement which aims at an integral realization of Painting.

However, we do not intend to provide definitions; we only wish to suggest that the joy of taking by surprise an art undefined within the limits of the painting, is worth the effort it demands, and to incite to this effort whoever is worthy of the task.

If we fail, what is the loss! To tell the truth, we are impelled by the pleasure man takes in speaking of the work to which he dedicates his daily life, and we firmly believe that we have said nothing that will fail to confirm real Painters in their personal dilection [*dilection*].

I

To evaluate the importance of Cubism, we must go back to Gustave Courbet.

This master—after David and Ingres had magnificently brought to an end a secular idealism—instead of wasting himself in servile repetitions like Delaroche and the Devérias, inaugurated a yearning for realism which is felt in all modern work. However, he remained a slave to the worst visual conventions. Unaware that in order to discover one true relationship it is necessary to sacrifice a thousand surface appearances, he accepted without the slightest intellectual control everything his retina communicated. He did not suspect that the visible world only becomes the real world by the operation of thought, and that the objects which strike us with the greatest force are not always those whose existence is richest in plastic truths.

Reality is deeper than academic recipes, and more complex also. Courbet was like one who contemplates the Ocean for the first time and who, diverted by the play of the waves, does not think of the depths; we can hardly blame him, because it is to him that we owe our present joys, so subtle and so powerful.

Edouard Manet marks a higher stage. All the same, his realism is still below Ingres' idealism, and his *Olympia* is heavy next to the *Odalisque*. We love him for having transgressed the decayed rules of composition and for having diminished the value of anecdote to the extent of painting "no matter what." In that we recognize a precursor, we for whom the beauty of a work resides expressly in the work, and not in what is only its pretext. Despite many things, we call Manet a realist less because he represented everyday events than because he endowed with a radiant reality many potential qualities enclosed in the most ordinary objects.

After him there was a cleavage. The yearning for realism was split into superficial realism and profound realism. The former belongs to the Impressionists: Monet, Sisley, etc.; the latter to Cézanne.

The art of the Impressionists involves an absurdity: by diversity of color it tries to create life, yet its drawing is feeble and worthless. A dress shimmers, marvelous; forms disappear, atrophied. Here, even more than with Courbet, the retina predominates over the brain; they were aware of this and, to justify themselves, gave credit to the incompatibility of the intellectual faculties and artistic feeling.

However, no energy can thwart the general impulse from which it stems. We will stop short of considering Impressionism a false start. Imitation is the only error possible in art; it attacks the law of time, which is Law. Merely by the freedom with which they let

the technique appear, or showed the constituent elements of a hue, Monet and his disciples helped widen the horizon. They never tried to make Painting decorative, symbolic, moral, etc. If they were not great painters, they were painters, and that is enough for us to venerate them.

People have tried to make Cézanne into a sort of genius *manqué*: they say that he knew admirable things but that he stuttered instead of singing out. The truth is that he was in bad company. Cézanne is one of the greatest of those who orient history, and it is inappropriate to compare him to Van Gogh or Gauguin. He recalls Rembrandt. Like the author of the *Pilgrims of Emmaus*, disregarding idle chatter, he plumbed reality with a stubborn eye and, if he did not himself reach those regions where profound realism merges insensibly into luminous spirituality, at least he dedicated himself to whoever really wants to attain a simple, yet prodigious method.

He teaches us how to dominate universal dynamism. He reveals to us the modifications that supposedly inanimate objects impose on one another. From him we learn that to change a body's coloration is to corrupt its structure. He prophesies that the study of primordial volumes will open up unheard-of horizons. His work, an homogeneous block, stirs under our glance; it contracts, withdraws, melts, or illuminates itself, and proves beyond all doubt that painting is not—or is no longer—the art of imitating an object by means of lines and colors, but the art of giving to our instinct a plastic consciousness.

He who understands Cézanne, is close to Cubism. From now on we are justified in saying that between this school and the previous manifestations there is only a difference of intensity, and that in order to assure ourselves of the fact we need only attentively regard the process of this realism which, departing from Courbet's superficial realism, plunges with Cézanne into profound reality, growing luminous as it forces the unknowable to retreat.

Some maintain that such a tendency distorts the traditional curve. From where do they borrow their arguments, the future or the past? The future does not belong to them as far as we know, and one must be singularly naïve to seek to measure that which exists by that which exists no longer.

Under penalty of condemning all modern art, we must regard Cubism as legitimate, for it carries art forward and consequently is today the only possible conception of pictorial art. In other words, at present, Cubism is painting itself.

At this point we should like to destroy a widespread misapprehension to which we have already made allusion. Many consider that decorative preoccupations must govern the spirit of the new painters. Undoubtedly they are ignorant of the most obvious signs which make decorative work the antithesis of the picture. The decorative work of art exists only by virtue of its *destination;* it is animated only by the relations established between it and the given objects. Essentially dependent, necessarily incomplete, it must in the first place satisfy the mind so as not to distract it from the display which justifies and completes it. It is an organ.

A painting carries within itself its *raison d'être*. You may take it with impunity from a church to a drawing-room, from a museum to a study. Essentially independent, necessarily complete, it need not immediately satisfy the mind: on the contrary, it should lead it, little by little, toward the imaginative depths where burns the light of organization. It does not harmonize with this or that ensemble, it harmonizes with the totality of things, with the universe: it is an organism.

Not that we wish to belittle decoration in order to benefit painting; it is enough for us to prove that if wisdom is the science of putting everything in its place, then the majority of artists are far from possessing it. Enough decorative plastic art and pictorial decoration, enough confusion and ambiguity!

Let us not argue about the original goal of our art. Formerly the fresco incited the artist to present distinct objects which evoked a simple rhythm, and on which the light bloomed, serving a synchronic vision rendered necessary by the amplitude of the surfaces; today oil painting allows us to express supposedly inexpressible notions of depth, density, and duration, and encourages us to present, according to a complex rhythm, a veritable fusion of objects within a restricted space. As all preoccupation in art arises from the material employed, we ought to regard a preoccupation for decoration, if we find it in a painter, as an anachronistic artifice, useful only to conceal impotence.

Does the difficulty which even a sensible and cultivated public experiences in understanding art result from present conditions? It must be admitted, but it should lead to enjoyment. A man will enjoy today what exasperated him yesterday. The transformation is extremely slow, and the slowness is easily explained: how could comprehension evolve as rapidly as the creative faculties? It follows in their wake.

II

Dissociating, for convenience, things that we know to be indissolubly united, let us study, by means of form and color, the integration of the plastic consciousness.

To discern a form implies, besides the visual function and the faculty of moving oneself, a certain development of the mind; to the eyes of most people the external world is amorphous.

To discern a form is to verify it by a pre-existing idea, an act that no one, save the man we call an artist, can accomplish without external assistance.

Before a natural spectacle, the child, in order to coordinate his sensations and to subject them to mental control, compares them with his picture-book; culture intervening, the adult refers himself to works of art.

The artist, having discerned a form which presents a certain intensity of analogy with his pre-existing idea, prefers it to other forms, and consequently—for we like to force our preferences on others—he endeavors to enclose the quality of this form (the unmeasurable sum of the affinities perceived between the visible manifestation and the tendency of his mind) in a symbol likely to affect others. When he succeeds he forces the crowd, confronted by his integrated plastic consciousness, to adopt the same relationship he established with nature. But while the painter, eager to create, rejects the natural image as soon as he has made use of it, the crowd long remains the slave of the painted image, and persists in seeing the world only through the adopted sign. That is why any new form seems monstrous, and why the most slavish imitations are admired.

Let the artist deepen his mission more than he broadens it. Let the forms which he discerns and the symbols in which he incorporates their qualities be sufficiently remote from the imagination of the crowd to prevent the truth which they convey from assuming a general character. Trouble results when the work is a kind of unit of measurement indefinitely applicable to several categories, both natural and artistic. We concede nothing to the past: why, then, should we favor the future by facilitating the task of the vulgarizer? Too much lucidity miscarries: let us beware of masterpieces. Propriety demands a certain degree of dimness, and propriety is one of the attributes of art.

Above all, let no one be decoyed by the appearance of objectivity with which many imprudent artists endow their pictures. There are

no direct means of evaluating the processes thanks to which the rela-
tions between the world and the thought of a man are rendered
perceptible to us. The fact commonly invoked, that we find in a
painting the familiar characteristics of the sight which motivated it,
proves nothing at all. Let us imagine a landscape. The width of the
river, the thickness of the foliage, the height of the banks, the
dimensions of each object and the relations of these dimensions—
these are secure guarantees. Well, if we find these intact upon the
canvas, we shall have learned nothing as to the talent or the genius
of the painter. The worth of river, foliage, and banks, despite a
conscientious faithfulness to scale, is no longer measured by width,
thickness, and height, nor the relations between these dimensions.
Torn from natural space, they have entered a different kind of
space, which does not assimilate the proportion observed. This
remains an external matter. It has just as much importance as a
catalogue number, or a title at the bottom of a picture-frame. To
contest this is to deny the space of painters; it is to deny painting.

The painter has the power of rendering enormous that which
we regard as minuscule, and as infinitesimal that which we know
to be considerable: he changes quantity into quality.

Only when decades and centuries have come to our aid, when
thousands of minds have corroborated one another, only when
innumerable plagiarists have enfeebled the noble enigma that a
picture is by commenting upon it, then, perhaps, we shall be able
to speak, without ridicule, of objective criticism.

To whom shall we impute the misapprehension? To the painters
who disregard their rights. When from any spectacle they have
separated the features which summarize it, they believe themselves
constrained to observe an accuracy which is truly superfluous. Let
us remind them that we visit an exhibition to contemplate painting
and to enjoy it, not to enlarge our knowledge of geography, anat-
omy, etc.

Let the picture imitate nothing and let it present nakedly its
raison d'être! Then we should indeed be ungrateful were we to
deplore the absence of all those things—flowers, or landscape, or
faces—whose mere reflection it might have been. Nevertheless, let
us admit that the reminiscence of natural forms cannot be abso-
lutely banished; as yet, at all events. An art cannot be raised all at
once to the level of a pure effusion.

This is understood by the Cubist painters, who tirelessly study
pictorial form and the space which it engenders.

This space we have negligently confused with pure visual space or with Euclidean space.

Euclid, in one of his postulates, speaks of the indeformability of figures in movement, so we need not insist upon this point.

If we wished to tie the painter's space to a particular geometry, we should have to refer it to the non-Euclidean scientists; we should have to study, at some length, certain of Riemann's theorems.

As for visual space, we know that it results from the harmony of the sensations of convergence and accommodation of the eye.

For the picture, a flat surface, the accommodation is negative. Therefore the convergence which perspective teaches us to simulate cannot evoke the idea of depth. Moreover, we know that the most serious infractions of the rules of perspective will by no means compromise the spatiality of a painting. Do not the Chinese painters evoke space, despite their strong partiality for *divergence?*

To establish pictorial space, we must have recourse to tactile and motor sensations, indeed to all our faculties. It is our whole personality which, contracting or expanding, transforms the plane of the picture. As it reacts, this plane reflects the personality back upon the understanding of the spectator, and thus pictorial space is defined: a sensitive passage between two subjective spaces.

The forms which are situated within this space spring from a dynamism which we profess to dominate. In order that our intelligence may possess it, let us first exercise our sensitivity. There are only *nuances*. Form appears endowed with properties identical to those of color. It is tempered or augmented by contact with another form, it is destroyed or it flowers, it is multiplied or it disappears. An ellipse may change its circumference because it is inscribed in a polygon. A form more emphatic than those which surround it may govern the whole picture, may imprint its own effigy upon everything. Those picture-makers who minutely imitate one or two leaves in order that all the leaves of a tree may seem to be painted, show in a clumsy fashion that they suspect this truth. An illusion, perhaps, but we must take it into account. The eye quickly interests the mind in its errors. These analogies and contrasts are capable of all good and all evil; the masters felt this when they strove to compose with pyramids, crosses, circles, semicircles, etc.

To compose, to construct, to design, reduces itself to this: to determine by our own activity the dynamism of form.

Some, and they are not the least intelligent, see the aim of our technique in the exclusive study of volumes. If they were to add

that because surfaces are the limits of volumes, and lines those of surfaces, it suffices to imitate a contour in order to represent a volume, we might agree with them; but they are thinking only of the *sensation of relief*, which we consider insufficient. We are neither geometers nor sculptors; for us, lines, surfaces, and volumes are only nuances of the notion of fullness. To imitate only volumes would be to deny these nuances for the benefit of a monotonous intensity. We might as well renounce at once our vow of variety.

Between sculpturally bold reliefs, let us throw slender shafts which do not define, but which suggest. Certain forms must remain implicit, so that the mind of the spectator is the chosen place of their concrete birth.

Let us also contrive to cut by large restful surfaces any area where activity is exaggerated by excessive contiguities.

In short, the science of design consists in instituting relations between straight lines and curves. A picture which contained only straight lines or curves would not express existence.

It would be the same with a painting in which curves and straight lines exactly compensated one another, for exact equivalence is equal to zero.

The diversity of the relations of line to line must be indefinite; on this condition it incorporates quality, the unmeasurable sum of the affinities perceived between that which we discern and that which already existed within us; on this condition a work of art moves us.

What the curve is to the straight line, the cold tone is to the warm in the domain of color.

III

After the Impressionists had burned up the last Romantic bitumens, some believed in a renaissance, or at least the advent of a new art: the art of color. Some were delirious. They would have given the Louvre and all the museums of the world for a scrap of cardboard spotted with hazy pink and apple-green. We are not jesting. To these excesses we owe the experience of a bold and necessary experiment.

Seurat and Signac thought of schematizing the palette and, boldly breaking with an age-long habit of the eye, established optical mixture.

Noble works of art, by Seurat as well as by Signac, Cross, and

certain others, testify to the fertility of the Neo-Impressionist method; but it appears contestable as soon as we cease to regard it on the plane of superficial realism.

Endeavoring to assimilate the colors of the palette with those of the prism, it is based on the exclusive use of pure elements. Now the colors of the prism are homogeneous, while those of the palette, being heterogeneous, can furnish pure elements only insofar as we accept the idea of a *relative purity*.

Suppose this were possible. A thousand little touches of pure color break down white light, and the resultant synthesis should take place in the eye of the spectator. They are so disposed that they are not reciprocally annihilated by the optical fusion of the complementaries; for, outside the prism, whether we form an optical mixture or a mixture on the palette, the result of the sum of complementaries is a troubled grey, not a luminous white. This contradiction stops us. On the one hand, we use a special procedure to reconstitute light; on the other hand, it is implicitly admitted that this reconstitution is impossible.

The Neo-Impressionists will not claim that it is not light they have divided, but color; they know too well that color in art is a quality of light, and that one cannot divide a quality. It is still light that they divide. For their theory to be perfect, they ought to be able to produce the sensation of white with the seven fundamentals. Then, when they juxtapose a red and a blue, the violet obtained should be equivalent to the red plus the blue. It is nothing of the sort. Whether the mixture is effected on the palette or on the retina, the result always is less luminous and less intense than the components. However, let us not hasten to condemn the optical mixture; it causes a certain stimulation of the visual sense, and we cannot deny that herein lies a possible advantage. But in this latter case it is sufficient to juxtapose elements of the same hue, yet of unequal intensity, to give that color a highly seductive animation; it is sufficient to *graduate* them. On this point the Neo-Impressionists can readily convince us.

The most disturbing point of their theory is an obvious tendency to eliminate those elements called *neutral* which, on canvas or elsewhere, form the indefinite, and whose presence is betrayed by Fraunhofer rays even in the spectrum itself. Have we the right thus to suppress the innumerable combinations which separate a cadmium yellow from a cobalt violet? Is it permissible thus to reduce the limits imposed by the color-makers? Neither Seurat, Signac, nor

Cross, fundamentally painters, went so far as this; but others, desirous of absolute equivalence, the negation of living beauty, renounced all mixtures, misunderstood the gradation of colors, and confided the task of lighting their paintings to the pre-selected chromatics [*précellences chromatiques*] exactly determined by industry.

The law of contrast, old as the human eye and on which Seurat judiciously insisted, was promulgated with much clamor. Among those who flattered themselves most on being sensitive to it, none was sufficiently so to perceive that to apply the law of complementaries without tact is to deny it, since it is only of value by the fact of automatic application, and only demands a delicate handling of values.

It was then that the Cubists taught a new way of imagining light.

According to them, to illuminate is to reveal; to color is to specify the mode of revelation. They call luminous that which strikes the mind, and dark that which the mind has to penetrate.

We do not automatically associate the sensation of white with the idea of light, any more than black with the idea of darkness. We admit that a black jewel, even if of a matte black, may be more luminous than the white or pink satin of its case. Loving light, we refuse to measure it, and we avoid the geometric ideas of focus and ray, which imply the repetition—contrary to the principle of variety which guides us—of light planes and dark intervals in a given direction. Loving color, we refuse to limit it, and sober or dazzling, fresh or muddy, we accept all the possibilities contained between the two extreme points of the spectrum, between the cold and the warm tone.

Here are a thousand tints which escape from the prism, and hasten to range themselves in the lucid region forbidden to those who are blinded by the immediate.

IV

If we consider only the bare fact of painting, we attain a common ground of understanding.

Who will deny that this fact consists in dividing the surface of the canvas and investing each part with a quality which must not be excluded by the nature of the whole?

Taste immediately dictates a rule: we must paint so that no two portions of the same extent ever meet in the picture. Common

sense approves and explains: let one portion repeat another, and the whole becomes measurable. The art which ceases to be a fixation of our personality (unmeasurable, in which nothing is ever repeated), fails to do what we expect of it.

The inequality of parts being granted as a prime condition, there are two methods of regarding the division of the canvas. According to the first, all the parts are connected by a rhythmic artifice which is determined by one of them. This one—its position on the canvas matters little—gives the painting a center from which or toward which the gradations of color tend, according as the maximum or minimum of intensity resides there.

According to the second, in order that the spectator ready to establish unity himself may apprehend all the elements in the order assigned to them by creative intuition, the properties of each portion must be left independent, and the plastic continuity must be broken into a thousand surprises of light and shade.

Hence we have two methods apparently inimical.

However little we know of the history of art, we can readily find names which illustrate each. The interesting point is to reconcile them.

The Cubist painters endeavor to do so, and whether they partially interrupt the ties demanded by the first method or confine one of those forces which the second insists should be freely allowed to flash out, they achieve that superior disequilibrium without which we cannot conceive lyricism.

Both methods are based on the kinship of color and form.

Although of a hundred thousand living painters only four or five appear to perceive it, a law here asserts itself which is to be neither discussed nor interpreted, but rigorously followed:

Every inflection of form is accompanied by a modification of color, and every modification of color gives birth to a form.

There are tints which refuse to wed certain lines; there are surfaces which cannot support certain colors, repelling them to a distance or sinking under them as under too heavy a weight.

To simple forms the fundamental hues of the spectrum are allied, and fragmentary forms should assume sparkling colors.

Nothing surprises us so greatly as to hear every day someone praise the color of a picture and find fault with the drawing. The Impressionists provide no excuse for such absurdity. Although in their case we may have deplored the poverty of form and at the same time praised the beauties of their coloring, it was because we focused upon their role as precursors.

In any other case we flatly refuse to perpetrate a division contrary to the vital forces of the painter's art.

The impossibility of imagining form and color separately confers upon those that feel it the privilege of envisaging conventional reality in a useful manner.

There is nothing real outside ourselves, there is nothing real except the coincidence of a sensation and an individual mental direction. Far from us any thought of doubting the existence of the objects which strike our senses; but, being reasonable, we can only have certitude with regard to the images which they make blossom in our mind.

It therefore amazes us that well-meaning critics explain the remarkable difference between the forms attributed to nature and those of modern painting, by a desire to represent things not as they appear, but as they are. And how are they? According to them, the object possesses an absolute form, an essential form, and, in order to uncover it, we should suppress chiaroscuro and traditional perspective. What naïveté! An object has not one absolute form, it has several, it has as many as there are planes in the domain of meaning. The one which these writers point to is miraculously adapted to geometric form. Geometry is a science, painting is an art. The geometer measures, the painter savors. The absolute of the one is necessarily the relative of the other; if logic is alarmed at this, so much the worse! Will it ever prevent a wine from being different in the retort of the chemist and in the glass of the drinker?

We are frankly amused to think that many a novice may perhaps pay for his too literal comprehension of Cubist theory, and his faith in absolute truth, by arduously juxtaposing the six faces of a cube or the two ears of a model seen in profile.

Does it ensue from this that we should follow the example of the Impressionists and rely upon the senses alone? By no means. We seek the essential, but we seek it in our personality, and not in a sort of eternity, laboriously fitted out by mathematicians and philosophers.

Moreover, as we have said, the only difference between the Impressionists and ourselves is a difference of intensity, and we do not wish it to be otherwise.

As many images of the object as eyes to contemplate it, as many images of essence as minds to understand it.

But we cannot enjoy ourselves in isolation; we wish to dazzle others with that which we daily snatch from the sensate world, and in return we wish others to show us their trophies. From a reci-

procity of concessions there will arise those mixed images, which we hasten to confront with artistic creations in order to calculate what they contain of the objective, that is, of the purely conventional.

If the artist has conceded nothing to common standards, his work will inevitably be unintelligible to those who cannot, with a single beat of their wings, lift themselves to unknown planes. If, on the contrary, by feebleness or lack of intellectual control, the painter remains enslaved to the forms in common use, his work will delight the crowd—his work? the crowd's work—and will sadden the individual.

Among so-called academic painters some may be gifted; but how could we know it? Their painting is so truthful that it founders in truth, in that negative truth, the mother of morals and everything insipid which, true for the many, is false for the individual.

Does this mean that a work of art must necessarily be unintelligible to the majority? No, it is only a consequence, merely temporary, and by no means a necessity.

We should be the first to blame those who, to hide their weaknesses, should attempt to fabricate puzzles. Systematic obscurity is betrayed by its persistence. Instead of a veil which the intellect gradually pushes aside as it adventures toward progressive richnesses, it is merely a curtain hiding a void.

Moreover, let us note that because all plastic qualities guarantee a built-in emotion, and because every emotion certifies a concrete existence, it is enough for a picture to be well painted to assure us of its author's veracity, and that our intellective [*intellectif*] effort will be rewarded.

That people unfamiliar with painting should not spontaneously share our assurance is hardly surprising; that they become irritated is certainly senseless. Must the painter, to please them, take his painting by the wrong end and restore to things the commonplace appearance which it is his mission to strip away?

From the fact that the object is truly transubstantiated, so that the most practiced eye has some difficulty in discovering it, a great charm results. The picture which only surrenders itself slowly seems always to wait until we interrogate it, as though it reserved an infinity of replies to an infinity of questions. On this point let Leonardo da Vinci defend Cubism:

"We know well," says Leonardo, "that our sight, by rapid observations, discovers from one vantage point an infinity of forms; nevertheless it only understands one thing at a time. Suppose that you,

reader, were to see the whole of this page at a glance, and concluded instantly that it is full of various letters; you would not at the same moment know what letters they are, nor what they would mean. You would have to go from one word to another and from line to line if you would wish to know these letters, just as you would have to climb step by step to reach the top of a building, or else never reach the top."

Not to discern at first contact the individuality of the objects which motivate a painting has its great charm, true, but it is also dangerous. We reject not only synchronistic and primary images, but also fanciful occultism, an easy way out; if we condemn the exclusive use of common signs it is not at all because we think of replacing them by cabalistic ones. We will even willingly confess that it is impossible to write without using clichés, and to paint while disregarding familiar signs completely. It is up to each one to decide whether he should disseminate them throughout his work, mix them intimately with personal signs, or boldly plaster them, magical dissonances, tatters of the great collective lie, on a single point of the plane of higher reality which he sets aside for his art. A true painter takes into account all the elements which experience reveals to him, even if they are neutral or vulgar. A simple question of tact.

But objective or conventional reality, this world intermediate between another's consciousness and our own, never ceases to fluctuate according to the will of race, religion, scientific theory, etc., although humanity has labored from time immemorial to hold it fast. Into the occasional gaps in the cycle, we can insert our personal discoveries and contribute surprising exceptions to the norm.

We do not doubt that those who measure with the handle of their paintbrush soon discover that roundness does more to represent a round object than do dimensions, which are always relative. We are certain that even the least wise will quickly recognize that the claim of configurating [de configurer] the weight of bodies and the time spent in enumerating their different points of view, is as legitimate as that of imitating daylight by the clash of orange and blue. Then the fact of moving around an object to seize from it several successive appearances, which, fused into a single image, reconstitute it in time, will no longer make reasoning people indignant.

And those who mistake the bustle of the street for plastic dynamism will eventually appreciate the differences. People will finally

realize that there never was a Cubist technique, but simply a pictorial technique which a few painters exhibited with courage and diversity. In actual fact, they are reproached with displaying it to excess, and are urged to conceal their craft. How absurd! As though one were to tell a man to run, but not to stir his legs!

Moreover, all painters exhibit their craft, even those whose industrious delicacies upset the barbarians across the ocean. But one thing is true of the painter's methods, as well as of the writer's: by passing from hand to hand they grow colorless, insipid, and abstract.

The Cubist methods are far from being this, although they do not still shine with the hard brilliancy of new coin, and although an attentive study of Michelangelo permits us to say that they have their patent of nobility.

V

To carry out a work of art it is not enough to know the relations of color and form and to apply the laws that govern them; the artist must also contrive to free himself from the servitude inherent in such a task. Any painter of healthy sensitivity and sufficient intelligence can provide us with well-painted pictures; but only he can awaken beauty who is designated by Taste. We call thus the faculty thanks to which we become conscious of Quality, and we reject the notions of good taste and bad taste which correspond with nothing positive: a faculty is neither good nor bad, it is simply more or less developed.

We attribute a rudimentary taste to the savage who is delighted by glass beads, but we might with infinitely greater justice consider as a savage the so-called civilized man who, for example, can appreciate nothing but Italian painting or Louis XV furniture. Taste is valued according to the number of qualities it allows us to perceive; yet when this number exceeds a certain figure it diminishes in intensity and evaporates into eclecticism. Taste is innate; but like sensitivity, which enhances it, it is tributary to the will. Many deny this. What is more obvious, however, than the influence of the will on our senses? It is so apparent that as soon as we should wish it, we could isolate the high-pitched note of an oboe among the metallic thunders of an orchestra. Similarly we can succeed in savoring a certain quality whose existence is affirmed by reason alone.

Is the influence of the will upon taste intrinsically good or is it

evil? The will can only develop taste along a plane parallel to that of the consciousness.

If a painter of mediocre intellect strives to savor qualities which for him are only the abstract products of a line of reasoning, and if he thus tries to augment his little talent, which he owes only to his sensitivity, then there is no doubt that his painting will become execrable, false, and stilted. If a man of superior mind sets himself the same goal, he will draw miraculous advantages from it.

The will exerted on taste with a view to a qualitative possession of the world derives its merit from the subjugation of every conquest to the nature of the chosen material.

Without using any allegorical or symbolic literary artifice, but with only inflections of lines and colors, a painter can show in the same picture both a Chinese and a French city, together with the mountains, oceans, flora and fauna, peoples with their histories and their desires, everything which in exterior reality separates them. Distance or time, concrete thing or pure conception, nothing refuses to be said in the painter's tongue, any more than in that of the poet, the musician, or the scientist.

The more the notions that the painter subordinates to his art appear remote from it, the more its beauty is affirmed. Its difficulties grow proportionately. A mediocre artist shows some wisdom by contenting himself with acting upon notions long ago appropriated to painting. Is not a simple Impressionist notation preferable to these compositions brimful of literature, metaphysics, and geometry, all insufficiently *pictorialized* [*picturalisées*]? We want plastic integration: either it is perfect or it is not; we want style, and not a parody of style.

The action of the will on taste aids selection. By the way a neophyte supports the discipline we can verify his vocation.

Among the Cubist painters there are some who painfully pretend to be self-willed and profound; there are others who move freely in the highest planes. Among the latter—it is not our place to name them—restraint is only the clothing of fervor, as with the great Mystics.

Since it has been said that great painting died with the Primitives —why not great literature with Homer?—some, in order to resuscitate it, impudently plagiarize the old Italian, German, and French masters and, undoubtedly in order to modernize it, have chosen to bolster their industry by means which the ill-informed are tempted to attribute to Cubism. Because the language of these tricksters, a kind of Esperanto or Volapük, is understood by everyone, it was

soon claimed that they speak, or at least that they are about to
speak, that language of great art accessible to all. Let us have done
with an irksome misunderstanding.

That the ultimate end of painting is to reach the masses, we
have agreed; it is, however, not in the language of the masses that
painting should address the masses, but in its own, in order to move,
to dominate, to direct, and not in order to be understood. It is the
same with religions and philosophies. The artist who abstains
from any concessions, who does not explain himself and who tells
nothing, builds up an internal strength whose radiance shines all
around.

It is in consummating ourselves within ourselves that we shall
purify humanity, it is by increasing our own riches that we shall
enrich others, it is by setting fire to the heart of the star for our
intimate joy that we shall exalt the universe.

To sum up, Cubism, which has been accused of being a system,
condemns all systems.

The technical simplifications which have provoked such accusa-
tions denote a legitimate anxiety to eliminate everything that does
not exactly correspond to the conditions of the plastic material, a
noble vow of purity. Let us grant that it is a method, but let us not
permit the confusion of method with system.

For the partial liberties conquered by Courbet, Manet, Cézanne,
and the Impressionists, Cubism substitutes an indefinite liberty.

Henceforth objective knowledge at last regarded as chimerical,
and all that the crowd understands by natural form proven to be
convention, the painter will know no other laws than those of
Taste.

From then on, by the study of all the manifestations of physical
and mental life, he will learn to apply them. But if all the same he
ventures into metaphysics, cosmogony, or mathematics, let him be
content with obtaining their savor, and abstain from demanding
of them certitudes which they do not possess. In their depths one
finds nothing but love and desire.

A realist, he will fashion the real in the image of his mind, for
there is only one truth, ours, when we impose it on everyone. And
it is the faith in Beauty which provides the necessary strength.

Kandinsky
Reminiscences

Wassily Kandinsky (1866-1944) wrote more extensively than any other major artist of the twentieth century, and his writings have been as influential as his paintings. *Reminiscences (Rückblicke)* is a brief autobiography, and by far his most personal essay.

Kandinsky, raised in Moscow, gave up a budding legal career in 1896 to become a painter. He left Russia for Munich that year, and by 1901 had already formed the Phalanx, one of several artists' associations he sponsored. After traveling widely from 1903 to 1908 in North Africa, and Western Europe, he returned to Munich and settled in the nearby village of Murnau, where he remained until 1914. He was in Russia until 1922, and until the Communist Party turned upon abstract art, driving him again westward, Kandinsky was remarkably active as teacher, lecturer, and administrator in the arts.

Reminiscences appeared in 1913, in the midst of the Munich period of activity marked by the apocalpytic painting whose excitement Abstract Expressionism has taught us to relive, marked also by Kandinsky's role as the chief propagandist for German Expressionism, organizer of exhibitions, editor, essayist, and poet. Since 1911 he had been the chief figure in the famous *Blaue Reiter*, whose first exhibition had been held in the winter of 1911-1912. He and Franz Marc edited the *Blaue Reiter* almanac, and in 1912 also he published his most famous essay, *Concerning the Spiritual in Art*. *Reminiscences* has a remarkable calm, perhaps derived from the artist's satisfaction that at long last, now 47 years old, he had brought years of experience to

fruition and was being recognized. The calm must also
result from a markedly introspective mood. Though a native
Russian, Kandinsky had lived in Munich for many years,
and seems in this essay to be questioning his Russian
origins; that is, by going back to his youth, he was seeking
the "Russian" component of his art. The reader must an-
ticipate some puzzling phrases, and anecdotes or metaphors
difficult to fathom. Kandinsky chose to write in an evocative
manner bordering upon a stream of consciousness, in which
fragments from his youth well up without prior explana-
tion.

Reminiscences was published in Berlin, in 1913, by Her-
warth Walden, the energetic figure behind *Der Sturm,* whose
publications and exhibitions were of great significance for
the second and third decades of this century. It was the
major text in an album entitled *Kandinsky 1901-1913;* the
other writings were short notes on specific paintings. The
entire album was translated by Hilla Rebay at the time of
the Guggenheim Museum's memorial exhibition in 1945,
and included in the folio publication *Kandinsky. Rück-
blicke,* there called "Retrospects," was given a quite faith-
ful, but somewhat awkward translation that has required a
thorough reworking. I have preferred the *Der Sturm* edition
to the amended revision Kandinsky published in Russian
in 1918, because of its significance to the pre-war years, and
because it is the only version that has been influential in
the history of modern art.

Reminiscences

The first colors that made a strong impression on me were bright,
juicy green, white, carmine red, black, and yellow ochre. These
memories go back to the third year of my life. I saw these colors
on various objects which are no longer as clear in my mind as the
colors themselves.

Like all children, I was passionately fond of "riding." For this
purpose our coachman used to cut spiral stripes on thin branches,
peeling both layers of bark off the first stripe and only the top layer
from the second, so that my horse usually consisted of three colors:
the brownish yellow of the outer bark (which I did not like and
would gladly have seen replaced by another), the juicy green of the

underlayer of the bark (which I especially liked and which in withered condition still had something enchanting about it) and finally the color of the ivory white wood of the stick (that smelled damp and tempted one to lick it, but soon became sadly shrivelled and dry, which spoiled my pleasure in this white from the very beginning).

It seems to me that shortly before my parents left for Italy (whither I, as a three-year-old, and my nurse were taken), my grandparents moved into a new house. I have the impression that this house was still entirely empty, that neither furniture nor people were in it. In a room that was not large, there was only a clock on the wall. I stood all alone in front of it and enjoyed the white of the dial and the carmine red of the rose painted on it.

My Muscovite nurse was very much surprised that my parents would make so long a trip to admire "ruined buildings and old stones": "We have enough of these in Moscow." Of all these "stones" in Rome I remember only an impenetrable forest of heavy columns, the frightful forest of St. Peter's from which, it seems to me, my nurse and I could find no way out for a long, long time.

And then all of Italy colors into two black impressions. I am travelling with my mother in a black coach over a bridge (water below—dirty yellow, I believe): I was taken to a kindergarten in Florence. And again black—down steps into the black water, upon it a terrible long black boat with a black box in the center: we board a gondola in the night. Here also I develop a talent which made me famous "all over Italy" and sob with all my might.

There was a piebald horse (with yellow ochre body and bright yellow mane) in a game of horse race which my aunt[1] and I especially liked. We always followed a strict order: I was allowed one turn to have this horse under my jockeys, then my aunt one. To this day I have not lost my love for these horses. It is a joy for me to see one such horse in the streets of Munich: he comes into sight every summer when the streets are sprinkled. He awakens the sun living in me. He is immortal, for in the fifteen years that I have known him he has not aged. It was one of my first impressions when I moved to Munich that long ago—and the strongest. I stood still and followed him for a long time with my eyes. And a half-conscious but joyous promise stirred in my heart. It aroused the

[1] Elisabeth Ticheeff, who had a great and ineradicable influence on my entire development. She was my mother's oldest sister and played a very important part in her education. Many others, too, who came in contact with her will never forget her luminous spirit.

little horse of lead within me and joined Munich to the years of my childhood. This piebald horse suddenly made me feel at home in Munich. As a child I spoke a great deal of German (my maternal grandmother came from the Baltic). The German fairy tales which I had so often heard as a child came to life. The high, narrow roofs of the Promenaden Platz and the Maximilian Platz, which have now disappeared, old Schwabing, and particularly Au [a suburban district of Munich] which I once discovered by chance, transformed these fairy tales into reality. The blue tramway passed through the streets like the embodiment of a fairy breeze that makes breathing light and joyful. The yellow mailboxes sang like canary birds on the corners. I welcomed the inscription "Kunstmühle" [art mill] and felt that I was in a city of art, which was the same to me as a city of fairies. From these impressions came the medieval pictures which I later painted. Following good advice I visited Rothenburg ob der Tauber. I will never forget the constant changing, from the express train to the local, from the local to the trolley with its grass-covered rails, the shrill whistle of the long-necked locomotive, the clatter and whining of the sleepy rails, with an old peasant with large silver buttons who insisted on talking about Paris with me and whom I could scarcely understand. It was an unreal trip. I felt as if a magic power, against all the laws of nature, had set me back century after century, ever deeper into the past. I leave the tiny (improbable) station and go over a meadow into the city gate. Gates, ditches, narrow houses that reach their heads across to each other over the narrow lanes and look each other deep in the eye, the giant door of the inn, which leads directly into the dark, massive dining room, from the center of which heavy, broad, dark oak stairs lead to the rooms; the tiny room, and the sea of bright red roofs which I see from the window. It rained the whole time. Large, round rain drops landed on my palette, teasingly stretched out their hands to each other from afar, shivered and shook, suddenly and unexpectedly united, forming thin, clever cords, running quickly and playfully among the colors to slide into my sleeves here and there. I do not know where these studies have gone, they have disappeared. Only one picture remained from this trip. It is "The Old City" which I painted from memory after my return to Munich. It is sunny and I made the roofs just as red as I then knew how.

Even in this painting I was really chasing after a particular hour which was and always will be the nicest hour of the Moscow day. The sun is already low and has reached its greatest power, for

which it was searching the entire day, toward which it struggled the entire day. This image does not last long: a few minutes more and the sunlight will become red from exertion, ever redder, first cold, then warmer and warmer. The sun melts all Moscow into one spot which, like a mad tuba, sets one's whole inside, one's whole soul vibrating. No, this red unity is not the loveliest hour! It is only the final note of the symphony which brings every color to its greatest intensity, which lets, indeed forces, all Moscow to resound like the *fff* of a giant orchestra. Pink, lavender, yellow, white, blue, pistachio green, flame-red houses, churches—each an independent song—the raving green grass, the deep murmuring trees, or the snow, singing with a thousand voices, or the allegretto of the bare branches, the red, stiff, silent ring of the Kremlin walls, and above, towering over all like a cry of triumph, like a Hallelujah forgetful of itself, the long white, delicately earnest line of the Ivan Veliky Bell Tower. And upon its neck, stretched high and taut in eternal longing to the heavens, the golden head of the cupola, which is the Moscow sun amid the golden and colored stars of the other cupolas.

To paint this hour, I thought, would be the most impossible and the greatest joy of an artist.

These impressions repeated themselves every sunny day. They were a pleasure which shook me to the bottom of my soul, which raised me to ecstasy. And at the same time they were a torture because I felt that art in general and my powers in particular were far too weak in the face of nature. Many years were to pass before I came to the simple solution, through feeling and thinking, that the aims (and thus the means) of nature and art are essentially, organically, and by universal law different from each other—and equally great and equally strong. This solution, which today guides my work, which is so simple and utterly natural, does away with the unnecessary torture of the vain task that I had inwardly set myself in spite of its unattainability; it banished this torture, and as a result my joy in nature and art rose to untroubled heights. Since that time I have been able to enjoy both these world elements to the full. To this enjoyment is joined a tremendous feeling of thankfulness.

This solution liberated me and opened up new worlds. Everything "dead" trembled. Not only the stars, moon, woods, flowers of which the poets sing, but also a cigarette butt lying in the ashtray, a patient white trouser button looking up from a puddle in the street, a submissive bit of bark that an ant drags through the high grass in its strong jaws to uncertain but important destina-

tions, a page of a calendar toward which the conscious hand reaches
to tear it forcibly from the warm companionship of the remaining
block of pages—everything shows me its face, its innermost being,
its secret soul, which is more often silent than heard. Thus every
still and every moving point (= line) became equally alive and
revealed its soul to me. It was sufficient for me to "grasp" with my
whole being, with all my senses, the possibility and the existence
of that art which today is called "abstract" in contrast to "objec-
tive."

But at that time, in my student days when I could only give my
leisure hours to painting, I sought in spite of its apparent impos-
sibility to capture on the canvas a "color chorus" (as I called it)
which, bursting out of nature, forced itself into my very soul. I made
desperate efforts to express the *full power* of this clamor—but in
vain.

At the same time my soul was constantly kept in turmoil by
other, purely human upheavals, so that I did not know a peaceful
hour. It was the moment of the creation of an all-student organiza-
tion which would embrace not only the student body of one uni-
versity but also of all the Russian and ultimately all the western
European universities. The struggle of the students against the
cunning and undisguised University Law of 1885 continued un-
abated. "Unrests," violations of the old liberal Moscow traditions,
the destruction of already existing organizations by the administra-
tion, our new groups, the subterranean rumbling of political move-
ments, the development of spontaneity[2] on the part of the students,
all produced continually new experiences and made the strings of
the soul sensitive, receptive, especially susceptible to vibration.

Luckily politics did not completely ensnare me. Different studies

[2] This spontaneity or personal initiative is one of the happiest (unfor-
tunately far too little cultivated) sides of a life that has been pressed
into rigid forms. Every individual (corporate or personal) step is full of
consequence because it shakes the rigidness of life—whether it aims at
"practical results" or not. It creates an atmosphere critical of customary
appearances, which through dull habit constantly deaden the soul and
make it immovable. Thence the dullness of the masses about which freer
spirits have always had reason for bitter complaint. Corporative organiza-
tions should be so constituted that they have the most open form possible
and incline more to adapt to new phenomena and to adhere less to
"precedent," than has hitherto been the case. Each organization should
be conceived only as a transition to freedom, as a necessary bond which
is, however, as loose as possible and does not hinder great strides toward
a higher evolution.

gave me practice in "abstract" thinking, in learning to penetrate
into fundamental questions. Aside from my chosen specialty (eco-
nomics, in which I worked under the direction of a highly gifted
teacher and one of the most singular men I ever met in my life,
Prof. A. J. Tschuproff), I was powerfully attracted, sometimes
successively, sometimes simultaneously, to other, different fields:
Roman law (which enchanted me by its fine, conscious and highly
polished "construction," but which ultimately could not satisfy
me as a Slav because its unbending logic was much too cold, much
too rational), criminal law (which appealed to me particularly and
perhaps too exclusively through the then-new theory of Lombroso),
the history of Russian law and peasant law (which, in contrast to
Roman law, won my admiration and profound love as a liberation
and a happy solution to the fundamental problem of law),[3] eth-
nology, which touched upon this study (and through which I at
first thought I would reach the soul of the people), all these claimed
my attention and helped me to think in an abstract manner.

I loved all these studies and to this day I think with gratitude of
the hours of enthusiasm and perhaps inspiration which they gave
me. But these hours paled upon my first contact with art, which
alone had the power to lift me beyond time and space. Scholarly
work had never given me such experiences, inner tensions, and
creative moments.

However I found my powers too weak to feel justified in renounc-
ing other duties and leading what seemed to me at the time the
infinitely happy life of the artist. Furthermore, Russian life was
then especially dismal, my scholarly work was valued, and I decided
to become a scholar. In my chosen field of economics, nevertheless,
except for the profit question, I was only interested in purely
abstract theory. Banking, the practical side of money matters, was
to me insurmountably repulsive. However there was nothing for
me to do but take this into the bargain also.

[3] After the "emancipation" of the serfs in Russia, the regime gave them
a system of economic self-government, which, unexpectedly for many,
made the peasants politically mature, and their own tribunals where,
within certain limits, judges chosen by the peasants could settle disputes
and also punish criminal "offenses." And here the people found the most
human principle, to punish minor guilt severely and major guilt lightly
or not at all. The peasant's expression for this is: "According to the man."
There was thus no development of rigid law (as for example in Roman
law—especially *jus strictum!*), but an extremely flexible and free form
which was *not* decided *by appearance* but *solely by the spirit.*

At the same time I underwent two experiences which stamped my entire life and which shook me to the marrow. They were the French Impressionist exhibition in Moscow—particularly the "Haystack" by Claude Monet—and a production of Wagner in the Hof Theater: *Lohengrin*.

Previously I had only known realistic art, in fact exclusively the Russians, having often stood for long periods before the hand of Franz Liszt in the portrait by Repin, and the like. And suddenly for the first time I saw a *painting*. That it was a haystack the catalogue informed me. I could not recognize it. This nonrecognition was painful to me. I considered that the painter had no right to paint indistinctly. I dully felt that the object of the picture was missing. And I noticed with astonishment and confusion that the picture not only draws you but impresses itself indelibly on your memory and, completely unexpectedly, floats before your eyes even to the last detail. All this was unclear to me, and I could not draw the simple conclusions of this experience. But what was entirely clear to me—was the unsuspected power of the palette, which had up to now been hidden from me, and which surpassed all my dreams. Painting acquired a fairy-tale power and splendor. And unconsciously the object was discredited as an indispensable element of a painting. All in all I had the impression, though, that a tiny bit of my fairy-tale Moscow already existed on the canvas.[4]

Lohengrin, however, seemed to me a full realization of this Moscow. The violins, the deep bass tones, and, most especially, the wind instruments embodied for me then the whole impact of the hour of dusk. I saw all my colors in my mind's eye. Wild, almost insane lines drew themselves before me. I did not dare use the expression that Wagner had painted "my hour" musically. But it became entirely clear to me that art in general is much more powerful than I had realized and that, on the other hand, painting can develop just as much power as music possesses. And my inability

[4] The "light and air" problem of the Impressionists interested me little. I always found that the clever speeches about this problem had very little to do with painting. The theory of the Neo-Impressionists later appeared to me more important, since it was ultimately concerned with the *effect of colors* and left air in peace. Nevertheless I felt at first dimly, later quite consciously, that every theory that is founded on external means represents only an individual case, alongside of which many other cases can exist with equal validity; still later I understood that the external grows from the internal or is stillborn.

to discover these powers or even to seek them made my renunciation all the bitterer.

However I was never strong enough to carry out my duties to the disdain of all else and succumbed to the temptation that was too strong for me.

A scientific event cleared my way of one of the greatest impediments. This was the further division of the atom. The crumbling of the atom was to my soul like the crumbling of the whole world. Suddenly the heaviest walls toppled. Everything became uncertain, tottering and weak. I would not have been surprised if a stone had dissolved in the air in front of me and become invisible. Science seemed to me destroyed: its most important basis was only a delusion, an error of the learned, who did not build their godly structures stone by stone with a steady hand in transfigured light, but groped at random in the darkness for truth and blindly mistook one object for another.

Already as a child I knew the tormenting, happy hours of that inner tension which promises to take on a concrete form. These hours of inner trembling, of unclear longing calling for something we do not understand, which by day oppress the heart and fill the soul with unrest, and by night make us live through fantastic dreams full of horror and joy. Like many children and young people, I attempted to write poetry which sooner or later I tore up. I can remember that drawing released me from this condition, that is, that it let me live outside of time and space, so that I no longer felt myself. My father[5] noticed my love of drawing at an early age and had me take drawing lessons while still at the *Gymnasium*. I recall how I loved the material itself, how the colors and crayons were especially alluring, beautiful, and alive. From the mistakes I

[5] With unusual patience my father allowed me to follow my dreams and whims during my entire life. When I was ten years old he tried to guide me to a choice between the Latin *Gymnasium* and the *Realschule:* by describing the differences between these schools, he helped me to make my choice as independently as possible. For many long years he very generously supported me financially. In the reorientations of my life he spoke to me as an older friend and never exercised a trace of force on me in important matters. His principles of education were complete trust and the relationship of a friend to me. He knows how grateful I am to him. These lines should be a guide to parents, who try forcibly to turn their children (and those gifted artistically in particular) away from their true careers and thereby make them unhappy.

made, I drew lessons which still nearly all affect me with their orig-
inal force. As a very small child I painted a piebald horse with
watercolors; everything was finished down to the hoofs. My aunt
who helped me with my painting had to go out and suggested I
wait for the hoofs until her return. I remained alone in front of
the unfinished picture and suffered from the impossibility of putting
the last touches of color on the paper. This last task seemed so easy
to me. I thought if I made the hoofs very black they would certainly
be completely true to nature. I put as much black on the brush as
I could. One instant—and I saw four black, disgusting, ugly spots
utterly foreign to the paper, on the horse's feet. I felt desperate and
horribly punished! Later I understood very well the Impressionists'
fear of black, and still later it cost me a real struggle of the soul
to put pure black on the canvas. Such a misfortune as a child casts
a long shadow over many years of later life.

Other especially strong impressions that I experienced in my
student years and which again had a decisive influence on later
years were the Rembrandts in the Hermitage in St. Petersburg, and
my trip to the government district of Vologda, whither I was sent
as ethnographer and jurist by the Imperial Institute for Natural
Sciences, Anthropology, and Ethnography. My task was two-fold:
to study peasant criminal law among the Russian population (to
find out the principles of primitive law), and to collect the rem-
nants of their heathenish religion from the fishing and hunting
tribes of the gradually disappearing Syrians.

Rembrandt moved me deeply. The great division of Light and
Dark, the blending of secondary tones into the larger parts, the
melting together of these tones in these parts, which had the effect
of a giant antiphony at every distance and immediately reminded
me of Wagner's trumpets, revealed to me completely new possibili-
ties, superhuman powers of color in its own right and particularly
the intensification of power through juxtapositions [*Zusammen-
stellungen*], that is, contrasts. I saw that every large surface in itself
contained no fairy-tale quality, that each of these surfaces imme-
diately betrayed its derivation from the palette, but that this surface
actually acquired a fairy-tale effect through the other, contrasted
surface, so that its origin on the palette seemed unbelievable at
first glance. However it was not in my nature to apply a means
observed without further ado. Unconsciously I approached strange
pictures as I now approach "nature"; I greeted them with reverence
and deep joy, but felt, nevertheless, that this was a power foreign
to me. On the other hand I felt somewhat unconsciously that this

great division gives Rembrandt's pictures a quality that I had never seen before. I felt that his pictures "last a long time," and explained it to myself that I had first to exhaust *one* part continuously and then the *other*. Later I understood that this division magically produces on the canvas an element which originally seems foreign and inaccessible to painting—*time*.[6]

The pictures I painted ten to twelve years ago in Munich were to achieve this quality. I painted only three or four such pictures in which I wished to bury in each part an "infinite" number of initially hidden color tones. They had to remain completely *hidden*[7] at first (especially in the dark part), and only as time went on show themselves at first unclearly and tentatively, to the studiously attentive viewer, then resound more and more with an increasingly *"mysterious"* power. To my great astonishment I noticed that I was working according to Rembrandt's principle. That was an hour of bitter disappointment and of gnawing doubt about my own powers, of doubt about the possibility of finding my own means of expression. Soon it seemed to me "too cheap" to incorporate in this manner the elements that were then dearest to me—the hidden, time, the mysterious.

At that time I was working especially hard, often until late at night, when I would be interrupted in my work by total exhaustion and forced to go quickly to bed. Days during which I had not worked (rare as they were!) I considered lost and tormented myself about them. When the weather was at all decent I painted for one or two hours a day, mainly in old Schwabing which was then gradually developing into a part of Munich. During the period of my disillusionment with studio work and of pictures painted from

6 A simple case of the application of time.

7 During this period I acquired the habit of jotting down separate thoughts. Thus was composed *Concerning the Spiritual in Art* without my realizing it. The notes accumulated during a span of at least ten years. One of my first notes on the beauty of color in painting is the following: "The splendor of color in a painting must powerfully attract the viewer, and, at the same time, it must hide the underlying content." I meant by this the painterly content, though not yet in pure form (as I now understand it) but the feeling or feelings of the artist which he expresses in painting. At that time I still labored under the delusion that the viewer confronts the painting with an open soul and wants to harken to a language known to him. There exist such viewers (that is no delusion), but they are as rare as grains of gold in the sand. There are even viewers who, without any personal relationship to the language of the work, are able to give themselves to it and take from it. I have met such in my life.

memory I painted many landscapes in particular, which, however, did not give me much satisfaction, so that I later made finished paintings of very few of them. Wandering about with a paintbox, feeling in my heart like a hunter, did not seem to me as responsible as painting pictures in which I searched already at that time, half consciously, half unconsciously, for the compositional element. The word *composition* moved me spiritually, and I later made it my aim in life to paint a *"composition."* This word affected me like a prayer. It filled me with awe. In painting sketches I let myself go. I thought little of houses and trees, with my palette knife I spread colored stripes and spots on the canvas and let them sing as loud as I could. Within me resounded the hour before sunset in Moscow, before my eyes was the strong colorful scale of the Munich atmosphere, thundering in its deep shadows. Later, especially at home, always a profound disappointment. My colors seemed to me weak, flat, the whole study—an unsuccessful effort to capture the power of nature. How odd it was for me to hear that I exaggerated the colors of nature, that this exaggeration made my paintings incomprehensible and that my only salvation would be to "divide colors." The Munich critics (some of whom were very favorable toward me, especially at first[8]) tried to explain the "splendor of my colors" by Byzantine influences. Russian criticism (which almost without exception attacked me in unparliamentary language) found that I was deteriorating under the influence of Munich art. I saw for the first time in those days the distorted, uninformed, and unrestrained manner in which most critics proceed. This explains also the *sangfroid* with which intelligent artists receive the nastiest articles about themselves.

My inclination toward the "hidden," the concealed, saved me from the harmful side of folk art, which I saw for the first time in its true setting and original form on my trip to the governmental district of Vologda. I traveled first by railroad with the feeling that I was journeying to another planet, then several days by steamer on the quiet and self-absorbed Suchona River, later in a primitive coach through endless woods, between brightly-colored hills, over

[8] Even today many critics see talent in my earlier paintings, which is a good proof of their weakness. In later ones and in the most recent they find a confusion, a dead end, a decline, and, very often, a deceit, which is a good proof of the ever-increasing power of these paintings. I naturally am not referring to the Munich critics alone: for them—with very few exceptions—my books are malicious bungling. It would be too bad if their judgment were otherwise.

morasses and through sandy deserts. I was traveling all alone, which was immeasurably favorable for absorbing myself in my surroundings and in myself. During the day it was often burning hot, at night frosty, and I gratefully remember my coachmen often wrapping me up more warmly in my carriage blanket which had fallen off me in the shaking and bouncing of the springless coach. I came to villages where suddenly the whole population was clothed in gray from head to toe and had yellow-green faces and hair, or suddenly colorful costumes appeared which flitted about like bright, living pictures on two legs. I shall never forget the large wooden houses covered with carvings. In these wonderful houses I experienced something that has never repeated itself since. They taught me to move in the *picture*, to live in the picture. I still remember how I entered the room for the first time and stopped short on the threshold before the unexpected vision. The table, the benches, the great oven, important in Russian peasant houses, the wardrobes and every object were painted with bright-colored, large-figured decorations. On the walls folk paintings: a hero in symbolic representation, a battle, a painted folk song. The "red" corner ("red" is old Russian for "beautiful") thickly and completely covered with painted and printed pictures of saints; in front of this, a small, red-burning, hanging lamp which glowed and flourished like a knowing, gently-speaking, modest star, proudly living in and for itself. When I finally entered the room, I felt myself surrounded on all sides by painting, into which I had thus penetrated. The same feeling slumbered within me, unconsciously up to then, when I was in churches in Moscow and especially in the great cathedral of the Kremlin. On my next visit to this church after my return from the trip, this feeling revived in me perfectly clearly. Later I often had the same experience in Bavarian and Tyrolean chapels. Naturally the impression was differently colored each time since different elements formed this impression: Church! Russian Church! Chapel! Catholic Chapel!

I did many sketches—these tables and different ornaments. They were never trivial, and so strongly painted that the *object dissolved* itself in them. This impression, too, only became clear much later.

Probably not otherwise than through these impressions did my further desires take shape within me, the aims of my own art. I have for many years searched for the possibility of letting the viewer "stroll" in the picture, forcing him to forget himself and dissolve into the picture.

Often, too, I have succeeded: I have seen it in the observers. From

the unconsciously intended effect of painting on the painted object, which can dissolve itself through being painted, derived my ability to *overlook* the object within the painting. Much later, in Munich, I was once enchanted by an unexpected view in my studio. It was the hour of approaching dusk. I came home with my paintbox after making a study, still dreaming and wrapped up in the work I had completed, when suddenly I saw an indescribably beautiful picture drenched with an inner glowing. At first I hesitated, then I rushed toward this mysterious picture, of which I saw nothing but forms and colors, and whose content was incomprehensible. Immediately I found the key to the puzzle: it was a picture I had painted, leaning against the wall, standing on its side. The next day I attempted to get the same effect by daylight. I was only half-successful: even on its side I always recognized the objects, and the fine finish of dusk was missing. Now I knew for certain that the object harmed my paintings.

A frightening depth of questions, weighted with responsibility, confronted me. And the most important: what should replace the missing object? The danger of ornamentation was clear, the dead make-believe existence of stylized forms could only frighten me away.

Only after many years of patient work, of strenuous thinking, of numerous careful efforts, of constantly evolving ability to experience painterly forms purely and abstractly, and to penetrate even deeper into these immeasurable depths did I arrive at the forms of painting with which I work today, on which I work today, and which, I hope and desire, will develop much further.

It took a very long time before this question "What should replace the object?" received a proper answer from within me. Often I look back into my past and am desolate to think how much time I took for the solution. I have only one consolation: I could never bring myself to use a form which developed out of the application of logic—not purely from *feeling* within me. I could not think up forms, and it repels me when I see such forms. All the forms which I ever used came "from themselves," they presented themselves complete before my eyes, and it only remained to me to copy them, or they created themselves while I was working, often surprising me. With the years, I have now learned somewhat to control this creative power. I have trained myself not simply to let myself go, but to bridle the power working within me, to guide it. With the years I have understood that working with a pounding heart, with a straining breast (and thus aching ribs later), and with tension in

my whole body cannot suffice. It can, however, only exhaust the artist, not his work. The horse bears the rider with strength and speed. But the rider guides the horse. Talent carries the artist to great heights with strength and speed. But the artist guides his talent. This is the element of the "conscious," the "calculating" in his work, or whatever one wants to call it. The artist must know *his* talent through and through and, like a smart businessman, leave not the least bit unused and forgotten; instead he must exhaust, develop every particle to the maximum possible for him.

This development, this refinement of talent demands a great ability to concentrate, which on the other hand leads to the diminution of other abilities. I saw this clearly in myself. I never possessed a so-called good memory: in particular I was always incapable of learning numbers, names, even poems by heart. The multiplication table always presented insuperable difficulties, which I have not yet overcome and which brought my teachers to despair. From the outset I had to summon the aid of my visual memory, then it went better. In the state examination in statistics I quoted a whole page of numbers only because in my excitement I saw this page *in my mind's eye*. Similarly I was already able as a boy to paint pictures by heart at home that had especially fascinated me at exhibitions, insofar as my technical abilities permitted. Later I sometimes painted a landscape "from memory" better than after nature. Thus I painted "The Old City" and later made many colored Dutch and Arabian drawings. Thus, too, in a long street I could name all the stores by heart, without error, since I *saw* them before me. Entirely without consciousness I steadily absorbed impressions, sometimes so intensively and incessantly that I felt as if my chest were cramped and my breathing difficult. I became so overtired and overstuffed that I often thought with envy of clerks who were permitted and able to relax completely after their day's work. I longed for dull-witted rest, for eyes which Boecklin called "porter's eyes." I *had* however, to see without pause.

A few years ago I suddenly noticed that this ability had diminished. At first I was horrified, but later I understood that the powers that made continuous observation possible were being channeled in another direction through my more highly developed ability to concentrate, and could accomplish other things now more necessary to me. My capacity for absorbing myself in the spiritual life of art (and thus, too, of my soul) increased so greatly that I often passed external phenomena without noticing them, something that could never have happened before.

I did not force this ability on myself, as far as I understand it—it always lived organically within me, but in embryonic form.

When I was thirteen or fourteen I bought a paintbox with oil paints from money slowly saved up. The feeling I had at the time —or better: the experience of the color coming out of the tube—is with me to this day. A pressure of the fingers and jubilant, joyous, thoughtful, dreamy, self-absorbed, with deep seriousness, with bubbling roguishness, with the sigh of liberation, with the profound resonance of sorrow, with defiant power and resistance, with yielding softness and devotion, with stubborn self-control, with sensitive unstableness of balance came one after another these unique beings we call colors—each alive in and for itself, independent, endowed with all necessary qualities for further independent life and ready and willing at every moment to submit to new combinations, to mix among themselves and create endless series of new worlds. Some lie there as if already exhausted, weakened, petrified, as dead forces and living memories of bygone possibilities, not decreed by fate. As in struggle, as in battle fresh forces pour out of the tube, young forces replacing the old. In the middle of the palette is a curious world of the remnants of colors already used, which wander far from this source in their necessary embodiments on the canvas. Here is a world which, derived from the desires of pictures already painted, was also determined and created through accidents, through the puzzling play of forces alien to the artist. And I owe much to these accidents: they have taught me more than any teacher or master. Many an hour I studied them with love and admiration. The palette, which consists of the elements mentioned, which is itself a "work" and often more beautiful than many another work, should be valued for the pleasures which it offers. It sometimes seemed to me that the brush, which with unyielding will tore pieces from this living color creation, evoked a musical sound in this tearing process. Sometimes I heard a hissing of the colors as they were blending. It was like an experience that one could hear in the secret kitchen of the alchemist, cloaked in mystery.

How often and how maliciously this first paintbox jeered and laughed at me. One minute the color ran down from the canvas, another minute, a little later, it came in torn bits; one minute it was lighter, another darker; one minute it seemed to spring down from the canvas and swim in the air, another and it became gloomier and gloomier like a dead bird that draws near its disintegration —I do not know how all this happened.

Later I heard that a very well-known artist (I no longer remember

who it was) said: "In painting one look at the canvas, half a look at the palette, and ten at the model." It sounded very nice, but I soon discovered that it must be the other way around for me: ten looks at the canvas, one at the palette, a half at nature. Thus I learned to battle with the canvas, to come to know it as a being resisting my wish (= dream), and to bend it forcibly to this wish. At first it stands there like a pure chaste virgin with clear eye and heavenly joy—this pure canvas which itself is as *beautiful* as a painting. And then comes the willful brush which first here, then there, gradually conquers it with all the energy peculiar to it, like a European colonist, who pushes into the wild virgin nature, hitherto untouched, using axe, spade, hammer, and saw to shape it to his wishes. I have gradually learned not to see the resistant white of the canvas, to notice it only for instants (as a control), instead of seeing in it the tones that are to replace it—thus one thing slowly followed another.

Painting is a thundering collision of different worlds, intended to create a new world in, and from, the struggle with one another, a new world which is the work of art. Each work originates just as does the cosmos—through catastrophes which out of the chaotic din of instruments ultimately create a symphony, the music of the spheres. The creation of works of art is the creation of the world.

Thus these sensations of colors on the palette (and also inside the tubes, which resemble humans, spiritually powerful but unassuming in appearance, who suddenly in time of need reveal and bring to bear their hitherto concealed powers) became experiences of the soul. Furthermore, these experiences were the point of departure for ideas which ten to twelve years ago began consciously to assemble themselves and which led to the book *Concerning the Spiritual in Art*. This book was written by itself more than by me. I wrote down individual experiences which, I later noticed, hung together in an organic relationship. I felt more and more clearly that it is not a question in art of the "formal" but of an inner wish (= content) which imperatively determines the formal. A step forward—but which took me a shamefully long time—was the solution of the problem of art exclusively on the basis of internal necessity, which was capable of overthrowing all known rules and limitations at any moment.

Thus the realm of art drew farther and farther apart from the realm of nature for me, until I could thoroughly experience both as independent realms. This only happened in its full magnitude this year.

Here I touch on a recollection which in its time was a source of sorrows for me. When I came to Munich from Moscow with the feeling of being reborn, the forced labor behind me, the work of pleasure before me, I very soon ran up against a barrier to my emancipation which at least in the matter of time and in a new way enslaved me—working from a model.

I saw the then very famous school of Anton Azbé[9] crowded with students. Two or three models "sat for heads" or "stood as nudes." Students of both sexes and different nationalities gathered around these ill-smelling, indifferent, inexpressive, mostly characterless phenomena of nature being paid 50-70 pfennig per hour, covered the paper and the canvas carefully with a gentle rustling noise, and tried to copy precisely these people who meant nothing to them, anatomically, constructionally, and characteristically. They tried to convey the connection of the muscles through overlapping of lines, to show the modeling of the nostrils, of the lips through a special treatment of surfaces or line, to construct the whole head according to the "principle of the ball," and never thought for a moment, it seemed to me, about art. The play of lines of the nude often interested me a great deal. But sometimes it was repulsive to me. Some positions of certain bodies repelled me by the effect of the lines, and I had to force myself energetically to reproduce them. I was almost always fighting with myself. Only out on the street could I breathe freely again, and often succumbed to the temptation to "cut" school and capture Schwabing, the English garden, or the Isar parks after my fashion with my paintbox. Or I stayed home and tried to do a picture from memory, from study, or by imagination, that did not have all too much to do with the laws of nature. I was therefore considered lazy by my colleagues and often of little talent, which sometimes hurt me a great deal, since I clearly felt within me a love for work, diligence, and talent. Finally I isolated myself in these surroundings, felt myself a stranger and absorbed myself with all the greater intensity in my wishes.

[9] Anton Azbé was a gifted artist and a rare and kind person. Many of his numerous pupils studied with him free of charge. His constant reply to the apology for inability to pay was: "Just work very hard." He evidently had a very unhappy life. One could hear him laugh but never see it: the corners of his mouth were hardly raised, his eyes always remained sad. I do not know if the enigma of his lonely life was known to anyone. And his death was just as lonely as his life: he died all alone in his studio. In spite of his very great income, he left only a few thousand marks. Not until after his death did it become known just how generous he was.

However I considered it my duty to take the course in anatomy, something I did conscientiously and, in fact, twice. The second time I attended the colorful and vivacious course of Prof. Dr. Moillet. I drew the preparations, took lecture notes, smelled the air of corpses. But unconsciously it was peculiarly annoying to me to hear of the direct connection between anatomy and art. It even offended me—just as the instruction once offended me that the trunk of the tree "must always be represented joined to the ground." There was no one there who could help me out of these feelings, out of the entanglement in this darkness. It is true that I also never turned to anyone with my doubts. Even today I find that such doubts must be resolved alone within the soul and that otherwise one would profane one's own powerful solution.

Nevertheless, I soon found in those days that every head, no matter how "ugly" it seems in the beginning, is a perfected beauty. The natural law of construction which is manifested in each head so completely and indisputably gave the head its stroke of beauty. I often stood before an "ugly" model and said to myself: "How skillful." And it is endless skill that shows in every detail: each nostril for example always awakens in me the same feeling of admiration as the flight of the wild duck, the joining of the leaf with the branch, the swimming of the frog, the pouch of the pelican, etc., etc. This feeling of admiration for beauty, for skill, I immediately experienced at Prof. Moillet's lectures.

I had a dim feeling that I sensed secrets of a realm all its own. But I could not connect this realm with the realm of art. I visited the Alte Pinakothek and noticed that not one of the great masters had achieved the creative beauty and skill of the natural model: nature itself remained untouched. It seemed to me sometimes that it was laughing at these efforts. Much more often, though, it appeared to me in the abstract sense "divine": it wrought *its* creation, it went *its* way to *its* goals, which disappear in the mists, it lived in *its* realm, and I was strangely outside of it. How did it relate to art?

When some of my colleagues saw the work I had done at home they labelled me a "colorist." Some called me, not without malice, the "landscape painter." Both hurt me although I perceived the justice of these characterizations. All the more so! I sensed actually that I felt much more at home in the realm of color than in that of drawing. And I did not know how to help myself in the face of this threatening evil.

At that time Franz Stuck was "the foremost draughtsman in Germany" and I went to him—unfortunately only with my schoolwork.

He found everything rather distorted and advised me to work in the drawing class at the Academy for a year. I failed in the examination, which only angered but did not discourage me: in this examination drawings were praised which I quite correctly found stupid, talentless, and completely devoid of knowledge. After a year of work at home I went to Franz Stuck for the second time—this time only with sketches of paintings that I was not yet able to finish and with several landscape studies. He accepted me in his painting class and when I asked about my drawing, I received the reply that it was expressive. Already during my first work at the Academy, Stuck energetically opposed my "extravagances" in color and advised me to paint in black and white first in order to study form alone. He spoke with surprising love about art, about the play of forms, about the flow of forms into each other, and won my complete sympathy. I wanted to learn only drawing from him, since I noticed right away that he had little sensitivity to color, and I yielded entirely to his counsels. In the final analysis I remember this year of work with him gratefully, although I sometimes became bitterly angry. Stuck spoke little and sometimes not very clearly. After his criticism I sometimes had to ponder his utterances for a long time —but later I found them almost always good. With a single remark he remedied my unfortunate effect of being unable to finish a painting. He told me that I work too nervously, that I pluck out what is interesting in the first moment and then spoil this through the dry part of the work which comes too late: "I awaken with the idea: today I am permitted to do thus and so." This "I am permitted" revealed to me not only Stuck's deep love for art and great respect for it, but also the secret of serious work. And at home I finished my first painting.

For many more years, however, I was like a monkey in a net: the organic laws of construction entangled me in my desires, and only with great pain, effort, and struggle did I break through these "walls around art." Thus did I finally enter the realm of art, which like that of nature, science, political forms, etc., is a realm unto itself, is governed by its own laws proper to it alone, and which together with the other realms ultimately forms that great realm which we can only dimly divine.

Today is the great day of one of the revelations of this world. The interrelationships of these individual realms were illumined as by a flash of lightning; they burst unexpected, frightening, and joyous out of the darkness. Never were they so strongly tied together and never so sharply divided. This lightning is the child of the darkening of the spiritual heaven which hung over us, black, suffo-

cating, and dead. Here begins the great epoch of the spiritual, the revelation of the spirit. Father–Son–Holy Spirit.

As time went on I very gradually recognized that "truth" in general and in art specifically is not an X, not an always imperfectly known but immovable quantity, but that this quantity is constantly moving in slow motion. It suddenly looked to me like a slowly moving snail that scarcely seems to leave the spot, and draws behind it a slimy trail to which shortsighted souls remain glued. Here, too, I first noticed this important fact in art, and later I saw that in this case the same law prevails in the other areas of life as well. This movement of truth is very complicated: the untrue becomes true, the true untrue, some parts fall away like the shell of a nut, time smoothes this shell; for this reason some people mistake the shell for the nut and bestow on the shell the life of the nut; many wrestle over this shell, and the nut rolls on; a new truth falls as if from heaven and seems so precise, so stiff and hard, appears so infinitely high that some scramble on it as on a long wooden pole and are certain that this time they will reach heaven until it breaks and until the climbers fall back like frogs in the swamp, into the dark unknown. Man is often like a beetle, kept on its back: he waves his little arms in silent longing, grasps at every blade that anyone holds out to him, steadily believing he will find salvation in this blade. In the days of my "unbelief" I asked myself: who is holding me on my back? Whose hand is holding the blade before me and then snatching it away again? Or am I lying on the dusty, indifferent earth on my back and grasping after the blades that grow about me "of their own accord?" How often, however, did I feel this hand on my back and then another that pressed itself upon my eyes, so that I found myself in the darkness of night while the sun shone.

Art is like religion in many respects. Its development does not consist of new discoveries which strike out the old truths and label them errors (as is apparent in science). Its development consists of sudden illuminations, like lightning, of explosions, which burst like a fireworks in the heavens, strewing a whole "bouquet" of different shining stars about itself. This illumination shows new perspectives in a blinding light, new truths which are basically nothing more than the organic development, the organic growing of earlier wisdom which is not voided by the later, but as wisdom and truth continues to live and produce. The trunk of the tree does not become superfluous because of a new branch: it makes the branch possible. Would the New Testament have been possible without the Old? Would our epoch of the threshold of the "third" revelation be conceivable without the second? It is a branching of the original

tree trunk in which "everything begins." And the branching out, the further growth and ramification which often seem confusing and despairing, are the necessary steps to the mighty crown; the steps which in the final analysis create the green tree.

Christ did not come, in his own words, to overthrow the old law. When he declared: "You have been told . . . but I say unto you . . ." he brought the old material law as it had become his spiritual law: in contrast to the men of Moses' time, the men of his time had become capable of grasping and experiencing the laws "do not kill," "do not commit adultery," not only in the literal, material sense but also in the abstract form of the sin of thought.

The plain, precise, and hard idea, therefore, is not overthrown, but used as the step to further ideas growing from it. And these further, softer, less precise, and less material ideas are like tenderer, newer branches which pierce new holes in the air.

The worth of a fact is not determined on Christ's scale as an external, rigid deed but as an inner, flexible one. Here lies the root of the future revaluation of values which even today continues slowly, uninterruptedly to create, and at the same time is the root of the spirituality which we also gradually reach in the realm of art. In our time in a strongly revolutionary form. In this way I finally came to the point at which I considered non-objective art not as the abnegation of all earlier art but only as a vitally important division of an old trunk into two main branches[10] from which other branches grow that are essential for the formation of the green crown.

[10] By these two main branches I mean two different ways of executing art. *The virtuoso type* (which music has long known as a special approach and which in literature corresponds to the art of drama) rests on the more or less personal sensitivity and on the artistic, creative interpretation of "nature." (An important example—portraiture.) Nature is here also understood as meaning an already existing work created by another hand: the virtuoso work which grows out of it is of the same sort as a picture painted "after nature." Up to now, artists have as a rule suppressed the desire to create such virtuoso works, which is to be regretted. The so-called copy also belongs in this category: the copyist tries to come as close to the foreign piece of work as a very precise conductor to a foreign composition.

The other category is *the composition*, where the work derives mostly or exclusively "from within the artist," as has been the case in music for centuries. In this respect painting has caught up with music, and both have a constantly growing tendency to create "absolute" works, that is, completely "objective" works which, like the works of nature, grow "from themselves" purely according to laws as independent *beings*. These works are closer to an art of abstraction and perhaps they alone are destined to embody this art existing in abstraction in some unforeseeable time.

I felt this fact more or less clearly from the beginning and was always annoyed by the charge that I was trying to overthrow the old concept of painting. I never experienced this overthrow in my works: in them I felt only the inwardly logical, outwardly organic, unavoidable evolution of art. Gradually I became conscious of my earlier feeling of freedom, and the secondary demands that I made of art eventually disappeared. They disappeared in favor of a single demand: the demand of *inner* life in painting. To my astonishment I realized that this demand grew on the foundation which Christ set forth as the foundation for moral qualification. I realized that this view of art is Christian and that at the same time it shelters within itself the necessary elements for the reception of the "third" revelation, the revelation of the Holy Spirit.[11]

I consider it just as logical, however, that the painting of an object in art makes very great demands on the inner experience of the purely painterly form, that therefore an evolution of the observer in this direction is absolutely necessary and can in no way be avoided. Thus are created the conditions for a new atmosphere. In this atmosphere will be created much, much later the *pure art* which hovers before us in our fleeting dreams of today with an indescribable attraction.

I understood in time that my slowly developed (partly conquered)

[11] In this sense Russian peasant law, mentioned previously, is also Christian and should be contrasted to heathen Roman law. The inner qualification can be thus explained by bold logic: this deed is not a crime when committed by this person, though in general it would be considered a crime when committed by other people. Therefore: in this case a crime is not a crime. And further: absolute crime does not exist. (What a contrast to *nulla poena sine lege!*) Still further: not the act (real) but its root (abstract) constitutes the evil (and good). And finally: every act is ambivalent. It balances on the edge. The will gives it the push—it falls to right or left. The external flexibility and the inner precision are highly developed in this case in the Russian people, and I do not believe I exaggerate when I recognize a strong capacity for this type of development in general in the Russians. It is also no surprise that peoples who have developed under the often valuable principles of the Roman spirit, formal, externally very precise (one need only think of the *jus strictum* of an *earlier* period), react either with a shake of the head or with scornful condemnation to Russian life. Superficial observation especially allows one to see in this life, so curious to the foreign eye, only the softness and external flexibility, which is taken for unruliness, because the inner precision lies at a depth. And this has the result that free-thinking Russians show much more tolerance of other peoples than is shown to them. And that this tolerance in many cases turns into admiration.

tolerance of other works does not harm me in any way, that, quite
the reverse, it is very favorable to the one-sidedness of my endeavors.
For this reason I would like partly to limit, partly to enlarge the
saying "The artist should be one-sided," to read "The artist should
be one-sided in his works." The ability to experience the works of
others (which happens naturally and must happen in its own way)
renders the soul more sensitive, more capable of vibration, thereby
enriching, broadening, refining it and making it more able to
achieve its own aims. Experiencing the works of others is in the
broadest sense like experiencing nature. And can or should an artist
be blind and deaf? I would say that one approaches one's own work
with yet happier spirit, with calmer passion, when one sees that
other possibilities (which are infinite) are correctly (or more or less
correctly) exploited in art. As regards me personally, I love every
form which necessarily derives from the spirit, which is created from
the spirit. Just as I hate every form which is not.

I believe that the philosophy of the future besides studying the
nature of things will also study their spirit with especial attention.
Then will the atmosphere be created that will enable men as a
whole to feel the spirit of things, to experience this spirit even if
unconsciously, just as today the outward form of things is expe-
rienced unconsciously by mankind in general, which explains the
public's enjoyment of representational art. Thus will mankind
be enabled to experience first the spiritual in material objects and
later the spiritual in abstract forms. And through this new capacity,
which will be in the sign of the "spirit," the enjoyment of ab-
stract = absolute art comes into being.

My book *Concerning the Spiritual in Art* and also *The Blue
Rider* had as their main purpose to awaken this capacity, absolutely
necessary in the future, for infinite experiences of the spiritual in
material and in abstract things. The wish to arouse this blessed
power in men, which they have never had, was the major goal of
both publications.[12]

These two books were and are often misunderstood. They are
taken as "programs" and their authors are branded as theorizing
artists who have gone astray in brain-work and "perished." Nothing
was farther from my mind than an appeal to the intellect, to the

[12] My *Concerning the Spiritual* lay written and finished for two years
in my desk drawer. The possibilities of realizing *The Blue Rider* had not
worked out. Franz Marc smoothed the practical way for the first book.
The second he also supported through his fine, understanding, and tal-
ented spiritual cooperation and help.

brain. This task would still have been premature today and will lie before artists as the next, important, and unavoidable aim (= step) in the further evolution of art. Nothing can and will be dangerous any longer to the spirit once it is established and deeply rooted, not even therefore the much-to-be-feared brain-work in art.

After our Italian trip, already mentioned, and after a brief return to Moscow when I was scarcely five years old, my parents and my aunt, Elisabeth Ticheeff, to whom I owe no less than to my parents, travelled to Southern Russia (Odessa) for reasons of my father's health. There I later attended the *Gymnasium*, but always felt a passing guest in a city that was foreign to my whole family. The desire never left us to be able to return to Moscow, and the city developed a longing in my heart similar to that which Chekhov describes in his "Three Sisters." From the time I was thirteen my father took me to Moscow every summer and thus I finally moved there at eighteen with the feeling that I was home again at last. My father hails from Eastern Siberia, whither his parents had been banished from Western Siberia for political reasons. He received his education in Moscow and learned to love this city no less than his home. His deeply human and loving soul understands the "spirit of Moscow" and he knows the external Moscow equally well. It is always a pleasure for me to listen as he enumerates in a solemn voice, for example, the countless churches with their wonderful old names. No doubt here sounds an artist's soul. My mother is a born Muscovite and unites within herself the qualities which to me symbolize Moscow: external, striking beauty, serious and strict through and through; aristocratic simplicity; inexhaustible energy; a unique union of tradition with true free thinking, woven out of great nervousness, imposing majestic calm, and heroic self-mastery. In sum —the "white-stone," "gold-headed," "Mother-Moscow" in human form. Moscow: two-sidedness, complexity, intense movement, collisions and confusion in outward appearance, which ultimately forms an individual, unitary image; the same peculiarities in its inner life, which is incomprehensible to the foreign eye (hence the many, contradictory judgments of foreigners about Moscow) and which is nevertheless just as individual and in the last analysis as perfectly unitary—this totality of the outer and inner Moscow I believe to be the origin of my artistic endeavors. It is my painter's tuning fork. I have the feeling that it was always so, and that as time goes on, and thanks to external formal advances, I have painted and am now painting this "model," only with an always stronger expression, in more perfect form, more fundamental form. The digressions that

I have made, therefore, from this direct path were not harmful as a whole; a few dead signs where I lost my strength and which seemed to me sometimes the end of my work, were for the most part jumping-off points and rest stops, which made possible the next step.

In many things I must condemn myself, but I have always remained true to one thing—the inner voice, which set my goal in art and which I hope to follow to the last hour.

Boccioni
Futurist Sculpture

Umberto Boccioni (1882-1916), already established as one of the leading Futurist painters, began sculpture in the winter of 1911-1912. He had proven himself an able pamphleteer and was presumably the principal author of the Futurist painters' manifestos of 1910. His *Technical Manifesto of Futurist Sculpture* was published April 11, 1912, by the Direzione del Movimento Futurista in Milan, or at least it was given that date, the 11th being a superstitious preference of Marinetti, the founder of Futurism, whose lead Boccioni had followed since 1909. For an exhibition of his sculpture in the Galerie La Boëtie, Paris, June 20 to July 16, 1913, *"Iʳᵉ exposition de sculpture futuriste du peintre et sculpteur Futuriste Boccioni,"* Boccioni provided a preface and reproduced in French, with some alterations, the sculpture manifesto. A list of works completed the catalogue, whose excellent French was beyond Boccioni's powers and might well be due to Marinetti. The poet had lived in Paris for many years, and was there at the time of the exhibition because the catalogue advertises lectures by him and by Boccioni, June 22 and 27.

The preface appeared for the first time in the Paris exhibition catalogue, and was already slightly altered in its first Italian version, for the exhibition at the Galleria Sprovieri, Rome, December 6, 1913 to January 5, 1914. The text of the preface was several times reprinted from this second version, which is the source of the only English translation, in Raffaele Carrieri's *Futurism* (Milan, 1961), pp. 77-78. Because of elements unique to the Paris text, elements

which have been ignored since then, I have preferred it to the other.

I also use the French text of the sculpture manifesto, providing its first English translation as well. Although it was not the first appearance of the essay, it has unique elements which have been overlooked. For example, in the La Boëtie version, Boccioni recommends the use of "transparent planes of glass or celluloid," the Italian variants dropping the mention of celluloid; he suggests that for the sake of a special movement, "a little motor" could be added to a sculpture, an engaging idea that in the Italian is merely *"un qualsiasi congegno."* The answer seems to be that when confronting the French, from whom he had earlier absorbed much and whom he was anxious to rival, he was more specific and more deliberately daring. The French text of the manifesto tends to emphasize that side of his sculpture, embodied in works most of which were later destroyed, which mixed wood, plaster, metal and other substances in a way that now reminds us a bit of the "junk sculpture" of our generation. The Paris version has whole sentences that were never included in any of the Italian variants.

I append the works as they were listed in the catalogue to complete the presentation Boccioni made to his French colleagues, and to give us an essential idea of the objects which embodied the texts.

New translations are in any case necessary because of the inadequacies of existing ones. The most authoritative recent translation of the sculpture manifesto (in the Museum of Modern Art's catalogue of its Futurist exhibition in 1961) typically writes "never breaks away from the Phidian period and its decadence," instead of "from the period of Phidias and the artistic decadence which followed it," unaccountably it omits the last two of the eleven numbered conclusions. The translation in Carrieri's *Futurism* is literally absurd, rendering what is properly "a hellenized Gothic style that is industrialized in Berlin and enervated in Munich by heavy-handed professors" as "a sort of cheap Hellenic-inspired Gothic rubbish which has been industrialized in Berlin and emasculated with effeminate care by the moronic professors of Munich."

The most thorough documentation for Boccioni is found

in the *Archivi del Futurismo* edited by M. Drudi Gambillo
and T. Fiori (Vol. I, Rome, 1958), although the text of the
Paris preface is taken from Boccioni's *Opera Completa*
edited by Marinetti (Foligno, 1927), and the manifesto from
I Manifesti del Futurismo, also edited by Marinetti (Milan,
1914).

Preface, First Exhibition of Futurist Sculpture

The works that I present to the Parisian public are the point of
departure of my *Technical Manifesto of Futurist Sculpture* (Milan,
11 April 1912).

The traditional desire to capture a gesture in a line and, further-
more, the very nature and homogeneity of the materials employed
(marble or bronze), have helped make sculpture the static art par
excellence.

I therefore thought that one could obtain a basic dynamic ele-
ment by breaking down this unity of material into a certain number
of different substances, each of which could, by its very diversity,
characterize a difference of weight and expansion of the molecular
volumes.

The problem of dynamism in sculpture does not depend only on
the diversity of materials, but above all upon the interpretation
of the form. The search for naturalistic form removes sculpture
(and painting also) from both its origins and its ultimate end:
architecture.

Architecture is for sculpture what composition is for painting.
The absolute absence of architecture is the gravest fault of impres-
sionistic sculpture.

The pre-Impressionist study of form (following a process ana-
logous to that of the Greeks and of all the primitives) leads fatally
to dead form, and consequently to immobility. This immobility is
the principal characteristic of Cubist sculpture.

Between the *real* form and the *ideal* form, between the new form
(Impressionism) and the traditional concept (pre-Impressionist, that
is, always mechanically Greek), there is a form that is changing,
evolving, and one that has nothing to do with all the forms con-
ceived of until now. This double concept of form: *form in move-
ment* (relative movement) and *movement of the form* (absolute
movement) can alone render in the duration of time that instant

of plastic life as it was materialized, without cutting it apart by drawing it from its vital atmosphere, without stopping it in the midst of its movement, in a word, without killing it.

All these convictions impel me to search in sculpture not pure form, but *pure plastic rhythm;* not the construction of bodies, but the *construction of the action of bodies.* Thus I have as my ideal not a pyramidal architecture (static state), but a spiral architecture (dynamism). This is why a body in movement is not for me a body studied when immobile and afterwards modeled as though it were in motion. It is, on the contrary, a body in movement, a living reality absolutely *new* and *original.*

In order to present a body in movement, I take care not to give its trajectory, that is, its passage from one state of repose to another; instead I force myself to determine the unique form that expresses its *continuity in space.*

Every intelligent person will understand that this spiral, architectural construction must give birth to *sculptural simultaneity,* analogous to the pictorial simultaneity that we proclaimed and expressed in our first exhibition of Futurist painting in Paris (Galerie Bernheim, 5 February 1912).

Traditional sculptors make their statues revolve in front of the spectator, or the spectator around the statues. Any visual angle thus possible is limited to one side of the statue or sculptural group at a time. This process only serves to augment the immobility of the work. My spiral, architectural construction, on the other hand, creates before the spectator a continuity of forms which permit him to follow ideally (through the *form-force* sprung from the real form) a new, abstract contour which expresses the body in its material movements.

By its centrifugal direction, the form-force is the potential of the living form. It is thus in a more abstract way that one perceives form in my sculpture. The spectator should construct ideally a continuity (simultaneity) which is suggested to him by the form-forces equivalent to the expansive energy of the bodies.

My sculptural ensemble evolves in the space created by the depths of the volumes, while showing the thickness of each profile. Therefore my sculptural ensemble does not offer a series of rigid profiles, immobile silhouettes. Each profile carries in itself a clue to the other profiles, both those that precede and those that follow, forming altogether the sculptural whole.

My inspiration, moreover, seeks through assiduous research a complete fusion of environment and object, by means of the *interpenetration of the planes*. I propose to make the object live in its surroundings without making it the slave of fixed or artificial light, or of a supporting plane. I absolutely disdain the trompe-l'oeil procedure of impressionistic sculptors who, seeking distance from architectural severity, only succeeded in drawing too close to painting.

The conception of the sculptural object becomes the plastic result of the object and its environment, and thereby abolishes the distance which exists, for example, between a figure and a house 200 meters apart. This conception produces the extension of a body in the ray of light which strikes it, the penetration of a *void* into the *solid* which passes before it.

All this I obtain by uniting atmospheric blocks with more concrete elements of reality.

Therefore, if a spherical form (the plastic equivalent of a head) is traversed by the façade of a palace situated further back, the interrupted half-circle and the square façade which intercepted it will form a new unity, composed of environment + object.

One must completely forget the figure enclosed in its traditional line and, on the contrary, present it as the center of plastic directions in space.

Sculptors under the yoke of tradition and technique ask me with a frightened look how I could determine the outer contours of the sculptural ensemble, seeing that the figure's outer limit coincides with the very line determined by the material itself (clay, plaster, marble, bronze, wood or glass) isolated in space. The response is simple: in order that the outer edges of the sculptural entity die away little by little and lose themselves in space, I color in black or in grey the extreme edge of the contour, graduating and nuancing these colors until I obtain a central clarity. Thus I create an auxiliary chiaroscuro which forms a nucleus in the atmospheric environment (*first impressionistic result*). This nucleus serves to augment the force of the sculptural nucleus in its environment composed of plastic directions (*dynamism*).

When I think it inappropriate to use such colorations, I leave aside this material means of spreading out in nuances into space, and instead let live the sinuosities, the discontinuities, the burst of straight and curved lines, according to the direction which the movement of the body impresses on them.

We succeed therefore, in both cases, in rising finally above the loathsome continuity of the Greek, Gothic, and Michelangelesque figure.

Technical Manifesto of Futurist Sculpture

The sculpture that we can see in the monuments and exhibitions of Europe affords us so lamentable a spectacle of barbarism and lumpishness that my Futurist eye withdraws from it in horror and disgust.

We see almost everywhere the blind and clumsy imitation of all the formulae inherited from the past: an imitation which the cowardice of tradition and the listlessness of facility have systematically encouraged. Sculptural art in Latin countries is perishing under the ignominious yoke of Greece and of Michelangelo, a yoke carried with the ease of skill in France and Belgium, but with the most dreary stupefaction in Italy. We find in Germanic countries a ridiculous obsession with a hellenized Gothic style that is industrialized in Berlin and enervated in Munich by heavy-handed professors. Slavic countries, on the other hand, are distinguished by a chaotic mixture of Greek archaisms, demons conceived by Nordic literature, and monsters born of oriental imagination. It is a tangle of influence ranging from the Sibylline and excessive detail of the Asiatic spirit to the puerile and grotesque ingenuity of Laplanders and Eskimos.

In all these manifestations of sculpture, from the most mechanical to those moved by innovating currents, there persists the same error: the artist copies live models and studies classical statues with the artless conviction that he can find a style corresponding to modern feeling, without giving up the traditional concept of sculptural form. One must add also that this concept, with its age-old ideal of beauty, never gets away from the period of Phidias and the artistic decadence which followed it.

It defies explanation how generations of sculptors can continue to construct dummies without asking themselves why all the exhibition halls of sculpture have become reservoirs of boredom and nausea, or why inaugurations of public monuments, rendezvous of uncontrollable hilarity. This is not born out by painting which, by its slow but continuous renovations, harshly condemns the plagiaristic and sterile work of all the sculptors of our time. When on earth will sculptors understand that to strive to build and to create

with Egyptian, Greek, or Michelangelesque elements is just as absurd as trying to draw water from an empty well with a bottomless bucket?

There can be no renewal of an art if at the same time its essence is not renewed, that is, the vision and the concept of the line and masses which form its arabesque. It is not simply by reproducing the exterior aspects of life that art becomes the expression of its time; this is why sculpture as it was understood by artists of the past century and of today is a monstrous anachronism. Sculpture absolutely could not make progress in the narrow path it was assigned by the academic concept of the nude. An art which has to undress completely a man or woman in order to begin its emotive function, is stillborn.

Painting fortified, intensified, and enlarged itself thanks to the landscape and the surroundings that the Impressionist painters made act simultaneously on the human figure and on objects. It is by prolonging their efforts that we have enriched painting with our *interpenetration of planes* (*Technical Manifesto of Futurist Painting*, 11 April 1910). Sculpture will find a new source of emotion and, therefore, of style, by extending its plasticity into the immense domain which the human spirit has stupidly considered until now the realm of the subdivided, the impalpable, and the inexpressible.

One must start with the central nucleus of the object one wants to create, in order to discover the new forms which connect it invisibly and mathematically to the *visible plastic infinite* and to the *interior plastic infinite*. The new plasticity will thus be the translation in plaster, bronze, glass, wood, or any other material, of atmospheric planes that link and intersect things. What I have called *physical transcendentalism* (*Lecture on Futurist Painting* at the *Circolo artistico* in Rome, May 1911) can render plastically the sympathies and mysterious affinities which produce the reciprocal and formal influences of the objects' planes.

Sculpture should give life to objects by rendering their extension into space palpable, systematic, and plastic, because no one can deny any longer that one object continues at the point another begins, and that everything surrounding our body (bottle, automobile, house, tree, street) intersects it and divides it into sections by forming an arabesque of curves and straight lines.

There have been two modern attempts to renew sculpture: one is decorative, for the sake of the style, the other is decidedly plastic,

for the sake of the materials. The first remained anonymous and disordered, due to the lack of a technical spirit capable of coordinating it. It remained linked to the economic necessities of officialdom and only produced traditional pieces of sculpture more or less decoratively synthesized, and surrounded by architectural or decorative forms. All the houses and big buildings constructed with modern taste and intentions manifest this attempt in marble, cement, or sheets of metal.

The second attempt, more serious, disinterested, and poetic, but too isolated and fragmentary, lacked the synthesizing spirit capable of imposing a law. In any work of renovation, it is not enough to believe with fervor; one must also choose, hollow out, and then impose the route to be followed. I am referring to a great Italian sculptor: to Medardo Rosso, the only great modern sculptor who tried to enlarge the horizon of sculpture by rendering into plastic form the influences of a given environment and the invisible atmospheric links which attach it to the subject.

Constantin Meunier contributed absolutely nothing new to sculptural feeling. His statues are nearly always powerful fusions of the heroic Greek style and the athletic humility of the stevedore, the sailor, or the miner. His concept of plasticity and structure of sculpture in the round and bas-relief remained that of the Parthenon and the classical hero. He has, nevertheless, the very great merit of having been the first to try to ennoble subjects that before his time were despised, or else abandoned to realistic reproduction.

Bourdelle displays his personality by giving to the sculptural block a passionate and violent severity of masses that are abstractly architectonic. Endowed with the passionate, somber, and sincere temperament of a seeker, he could not, unfortunately, deliver himself from a certain archaicizing influence, nor of the anonymous influence of all the stone sculptors of Gothic cathedrals.

Rodin unfolded a greater intellectual agility, which permitted him to pass with ease from the Impressionism of his Balzac to the irresolution of his Burghers of Calais, and to all his other works marked by the heavy influence of Michelangelo. He displays in his sculpture a disquieting inspiration, a grandiose lyrical power, which would be truly modern if Michelangelo and Donatello had not already preceded him with nearly identical forms some four hundred years ago, and if his gifts could have brought to life a completely re-created reality.

One finds then in the work of these three talents the three influences of three different periods: Greek in Meunier's work, Gothic in Bourdelle's, Italian Renaissance in Rodin's.

The work of Medardo Rosso, on the other hand, is revolutionary, very modern, more profound, and of necessity restricted. There are hardly any heros or symbols in his sculptural work, instead the plane of the forehead of one of his women or children embodies and points to a release toward space which one day will have in the history of the human mind an importance far superior to that now acknowledged by contemporary critics. Unfortunately, the inevitably Impressionistic laws of his endeavor limited the researches of Medardo Rosso to a sort of high or low relief; it is proof that he still conceived of the figure as an isolated world, with a traditional essence and episodic intentions.

The artistic revolution of Medardo Rosso, although very important, starts from a pictorial point of view too much concerned with the exterior, and entirely neglects the problem of a new construction of planes. His sensual modeling, which tries to imitate the lightness of the Impressionists' brushstroke, creates a fine effect of intense and immediate sensation, but it makes him work too quickly after nature, and deprives his art of any mark of universality. The artistic revolution of Medardo Rosso thus has both the virtues and the faults of Impressionism in painting. Our Futurist revolution also began there but, although continuing Impressionism, it has come to the opposite pole.

In sculpture as well as in painting, one can renew art only by seeking the *style of movement*, that is, by forming systematically and definitively into a synthesis that which Impressionism offered in a fragmentary, accidental, and consequently analytical way. This systematization of the vibration of light and of the interpenetrations of planes will produce Futurist sculpture: it will be architectonic in character, not only from the point of view of the construction of the masses, but also because the sculptural block will contain the architectonic elements of the sculptural milieu in which the subject lives.

Naturally we will create a *sculpture of environment*. A Futurist sculptural composition will contain in itself the marvelous mathematical and geometric elements of modern objects. These objects will not be placed alongside the statue, like so many explanatory attributes or separate decorative elements but, following the laws of a new conception of harmony, they will be embedded in the muscular lines of a body. We will see, for example, the wheel of a motor projecting from the armpit of a machinist, or the line of a table cutting through the head of a man who is reading, his book in turn subdividing his stomach with the spread fan of its sharp-edged pages.

In the current tradition of sculpture, the statue's form is etched

sharply against the atmospheric background of the milieu in which it stands. Futurist painting has surpassed this conception of the rhythmic continuity of lines in a figure and of its absolute isolation, without contact with the background and the *enveloping invisible space*. "Futurist poetry," according to the poet Marinetti, "after having destroyed traditional prosody and created free verse, now abolishes syntax and the Latin interval. Futurist poetry is a spontaneous flow uninterrupted by analogies, each of which is intuitively summed up in its essential substantive. From this come *untrammeled imagination and liberated words*." "The Futurist music of Balilla Pratella destroys the chronometric tyranny of rhythm."

Why, then, should sculpture remain shackled by laws which have no justification? Let us break them courageously and proclaim the *complete abolition of the finished line and the closed statue. Let us open up the figure like a window and enclose within it the environment in which it lives.* Let us proclaim that the environment must form part of the plastic block as a special world regulated by its own laws. Let us proclaim that the sidewalk can climb up your table, that your head can cross the street, and that at the same time your household lamp can suspend between one house and another the immense spider-web of its dusty rays.

Let us proclaim that all the perceptible world must hurry toward us, amalgamating itself with us, creating a harmony that will be governed only by creative intuition. A leg, an arm, or any object whatsoever, being considered important only if an element of plastic rhythm, can easily be abolished in Futurist sculpture, not in order to imitate a Greek or Roman fragment, but to obey a harmony the sculptor wishes to create. A sculptural ensemble, like a painting, can only resemble itself, because in art the human figure and the objects should live outside of and despite all logic of appearances.

A figure can have an arm clothed and the rest of the body nude. The different lines of a vase of flowers can follow one another nimbly while blending with the lines of the hat and neck.

Transparent planes of glass or celluloid, strips of metal, wire, interior or exterior electric lights can indicate the planes, the tendencies, the tones and half-tones of a new reality. By the same token, a new intuitive modulation of white, grey, and black can augment the emotive force of the planes, while a colored plane can accentuate violently the abstract signification of a plastic value.

What we have already said about *line-forces* in painting (Preface-Manifesto of the Catalogue of the First Futurist Exhibition in Paris,

October 1911) applies equally to sculpture. In effect, we will give life to the static muscular line by merging it with the dynamic line-force. It will nearly always be a straight line, which is the only one corresponding to the interior simplicity of the synthesis that we oppose to the baroque exterior of analysis. However, the straight line will not lead us to imitate the Egyptians, the Primitives, and the savages, by following the absurd example of certain modern sculptors who have hoped that way to deliver themselves from Greek influence. Our straight line will be alive and palpitating; it will lend itself to the demands of the infinite expressions of materials, and its fundamental, naked severity will express the severity of steel, which characterizes the lines of modern machinism. Finally, we can affirm that the sculptor must not shrink from any means in order to obtain a *reality*. Nothing is more stupid than to fear to deviate from the art we practice. There is neither painting, nor sculpture, nor music, nor poetry. The only truth is creation. Consequently, if a sculptural composition needs a special rhythm of movement to augment or contrast the fixed rhythm of the *sculptural ensemble* (necessity of the work of art), then one could use a little motor which would provide a rhythmic movement adapted to a given plane and a given line.

One must not forget that the tick-tock and the movement of the hands of a clock, the rise and fall of a piston in its cylinder, the meshing and unmeshing of two gears with the continual disappearance and reappearance of their little steel rectangles, the frenzy of a fly-wheel, the whirl of a propeller, all these are plastic and pictorial elements of which Futurist sculptural work must make use. For example: a valve opening and closing creates a rhythm as beautiful but infinitely newer than that of a living eyelid.

Conclusions

1. The aim of sculpture is the abstract reconstruction of the planes and volumes which determine form, not their figurative value.

2. One must *abolish in sculpture,* as in all the arts, the *traditionally exalted place of subject matter.*

3. Sculpture cannot make its goal the episodic reconstruction of reality. It should use absolutely all realities in order to reconquer the essential elements of plastic feeling. Consequently, the Futurist sculptor perceives the body and its parts as *plastic zones,* and will introduce into the sculptural composition planes of wood or metal,

immobile or made to move, to embody an object; spherical and hairy forms for heads of hair; half-circles of glass, if it is a question of a vase; iron wires or trellises, to indicate an atmospheric plane, etc., etc.

4. It is necessary to destroy the pretended nobility, entirely literary and traditional, of marble and bronze, and to deny squarely that one must use a single material for a sculptural ensemble. The sculptor can use twenty different materials, or even more, in a single work, provided that the plastic emotion requires it. Here is a modest sample of these materials: glass, wood, cardboard, cement, concrete, horsehair, leather, cloth, mirrors, electric lights, etc.

5. It is necessary to proclaim loudly that in the intersection of the planes of a book and the angles of a table, in the straight lines of a match, in the frame of a window, there is more truth than in all the tangle of muscles, the breasts and thighs of heros and Venuses which enrapture the incurable stupidity of contemporary sculptors.

6. It is only by a very modern choice of subject that one can succeed in discovering *new plastic ideas.*

7. The straight line is the only means that can lead us to the primitive virginity of a new architectonic construction of sculptural masses and zones.

8. There can be a reawakening only if we make a *sculpture of milieu or environment,* because only this way can plasticity be developed, by being extended into space in order to model it. By means of the sculptor's clay, the Futurist today can at last *model the atmosphere* which surrounds things.

9. What the Futurist sculptor creates is to a certain extent an ideal bridge which joins the exterior plastic infinite to the interior plastic infinite. It is why objects never end; they intersect with innumerable combinations of attraction and innumerable shocks of aversion. The spectator's emotions will occupy the center of the sculptural work.

10. One must systematically destroy the nude and the traditional concept of the statue and the monument.

11. Finally, one must at all cost refuse commissions of subjects determined in advance, and which therefore cannot contain a pure construction of completely renewed plastic elements.

Umberto Boccioni
Painter and sculptor
Milan, 11 April 1912.

Plastic Ensembles

1. Muscles moving swiftly.
2. Synthesis of human dynamism.
3. Spiral expansion of muscles in motion.
4. Head + Houses + Light.
5. Fusion of a head and a window-frame.
6. Development by form of a bottle in space (Still life).
7. Form-forces of a bottle (Still life).
8. Abstract voids and solids of a head.
9. Antigracious [*antigracieux*].
10. Unique forms of continuity in space.
11. Development by color of a bottle in space (Still life).

Drawings

1 to 6: I wish to synthesize the unique forms of continuity in space.
7 to 15: I wish to capture human forms in motion.
16: I wish to make a head merge with its environment.
17: I wish to extend objects into space.
18 to 22: I wish to model light and air.

Le Corbusier & Ozenfant
Purism

Purism appeared in the fourth issue of *L'Esprit Nouveau* and is the most succinct essay of many in which Jeanneret and Ozenfant defined their new movement. (In his role as architect, Jeanneret took the name "Le Corbusier" beginning in 1921.)

The two artists apparently met for the first time in 1917. Charles-Édouard Jeanneret (born 1887), a Swiss who took French citizenship, had behind him a decade of architectural study and work. From 1912 to 1916, after a long period of travel, he settled in La Chaux-de-Fonds, and then in 1917 came to Paris. Amadée Ozenfant (born 1886) had been painting in the capital, and the same year had published a retrospective critique of Cubism in the review *L'Élan*. The two men began a close collaboration, whose first fruits included the book *Après le Cubisme* (Paris, 1918), and the formal establishment of Purism as a movement with the first Purist exhibition, also in 1918, in the Galerie Thomas. From 1920 to 1925, their review *L'Esprit Nouveau* was one of the focuses for the rationalist, post-Cubist strain that opposed itself to Dada and Surrealism. Their book *La Peinture Moderne* was published in 1925, marking the end of their association. Le Corbusier thereafter pursued a career that has given him world-wide fame as an architect, painting being essentially an avocation for him. Ozenfant published *Foundations of Modern Art* in 1928, and this most delightful and stimulating book has earned several English editions.

Le Purisme appeared in the fourth issue of *L'Esprit Nouveau,* 1920, pp. 369-386. Although it is hard to choose

from the many essays in which Ozenfant and Jeanneret set
forth their ideas, this one seems to embody the essence of
Purism in the most perfect form. It is the ideal coupling of
their respective origins in painting and architecture, so
much so that even after a careful reading of their earlier
and later individual writings, it is hard to pluck from the
essay each man's independent contribution. Lest Jeanneret-
Corbusier's subsequent fame lead the reader to assume his
role was pre-eminent, he need only look at Ozenfant's writ-
ings in *L'Élan* of 1917. The admirer of Le Corbusier might
well be surprised to find that this joint essay of 1920 con-
tains already—some in full statement, others in embryo—all
the cardinal principles of his esthetic.

This, the first translation, maintains with great care the
clipped and precise language that so beautifully suited the
"machine esthetic" of Purism. It also uses equivalents for
the coined words that help form the essay's spirit: "archi-
tecturé" is rendered "architectured," for example, because
the artists deliberately chose it in preference to the correct
"architectural," which had less force for them.

I am most grateful to Ozenfant and Le Corbusier for
authorizing me to translate and publish this essay.

Purism

INTRODUCTION: Logic, the human factor, fixed points.
THE WORK OF ART: Its goal, hierarchy, order.
SYSTEM: Primary sensations, secondary sensations, ornamental art,
 symbolic art, the theme-object, natural selection, mechanical
 selection, choice of theme-object, the Purist element.
CONCEPTION.
COMPOSITION: Choice of surface, geometric locations, regulating
 lines, modules, values, color.
SENSITIVITY.
PURISM.

Introduction

Logic, born of human constants and without which nothing is
human, is an instrument of control and, for he who is inventive, a
guide toward discovery; it controls and corrects the sometimes ca-

pricious march of intuition and permits one to go ahead with certainty.

It is the guide that sometimes precedes and sometimes follows the explorer; but without intuition it is a sterile device; nourished by intuition, it allows one "to dance in his fetters."

Nothing is worthwhile which is not general, nothing is worthwhile which is not transmittable. We have attempted to establish an esthetic that is rational, and therefore human.

It is impossible to construct without fixed points. We already sought in an earlier article[1] to determine some of these.

The Work of Art

The work of art is an artificial object which permits the creator to place the spectator in the state he wishes; later we will study the means the creator has at his disposal to attain this result.

With regard to man, esthetic sensations are not all of the same degree of intensity or quality; we might say that there is a hierarchy.

The highest level of this hierarchy seems to us to be that special state of a mathematical sort to which we are raised, for example, by the clear perception of a great general law (the state of mathematical lyricism, one might say); it is superior to the brute pleasure of the senses; the senses are involved, however, because every being in this state is as if in a state of beatitude.

The goal of art is not simple pleasure, rather it partakes of *the nature of happiness*.

It is true that plastic art has to address itself more directly to the senses than pure mathematics which only acts by symbols, these symbols sufficing to trigger in the mind consequences of a superior order; in plastic art, the senses should be strongly moved in order to predispose the mind to the release into play of subjective reactions without which there is no work of art. But there is no art worth having without this excitement of an intellectual order, of a mathematical order; architecture is the art which up until now has most strongly induced the states of this category. The reason is that everything in architecture is expressed by order and economy.

The means of executing a work of art is a transmittable and universal language.

1 "Sur la plastique," *L'Esprit Nouveau* [I], 1, 15 Octobei 1920 [pp. 38-48].

One of the highest delights of the human mind is to perceive the order of nature and to measure its own participation in the scheme of things; the work of art seems to us to be a labor of putting into order, a masterpiece of human order.

Now the world only appears to man from the human vantage point, that is, the world seems to obey the laws man has been able to assign to it; when man creates a work of art, he has the feeling of acting as a "god."

Now a law is nothing other than the verification of an order.

In summary, a work of art should induce a sensation of a mathematical order, and the means of inducing this mathematical order should be sought among universal means.

System

One cannot, therefore, hope to obtain these results by the empirical and infinitely impure means that are used habitually.

Plastic art, modern architecture, modern painting, modern sculpture, use a language encumbered by terms that are confused, poorly defined, undefinable. This language is a heterogeneous mixture of means used by different and successive schools of esthetics, nearly all of which considered only the release of the sensations of immediate feeling; it does not suit the creation of works which shall have what we demand.

We established in our article "On the Plastic" that there are two quite distinct orders of sensation:

1. Primary sensations determined in all human beings by the simple play of forms and primary colors. *Example:* If I show to everyone on Earth—a Frenchman, a Negro, a Laplander—a sphere in the form of a billiard ball (one of the most perfect human materializations of the sphere), I release in each of these individuals an identical sensation inherent in the spherical form: *this is the constant primary sensation.*

The Frenchman will associate with it ideas of sport, billiards, the pleasures or displeasures of playing, etc.—variables. The Laplander or the Negro may not associate any idea with it at all or, on the other hand, they might associate with it an idea of divinity: *there is thus a constant, fixed sensation released by the primary form.*

[2.] There are secondary sensations, varying with the individual because they depend upon his cultural or hereditary capital. *Example:* If I hold up a primary cubic form, I release in each individ-

ual the same primary sensation of the cube; but if I place some black geometric spots on the cube, I immediately release in a civilized man an idea of dice to play with, and the whole series of associations which would follow.

A Papuan would only see an ornament.

There are, therefore, besides the primary sensation, infinitely numerous and variable secondary sensations. The primary sensation is constant for every individual, it is universal, it can be differentiated by quantity, but it is *constant in quality:* there are some people who have thick skins. This is a capital point, a fixed point.

What we have said for the cube and the sphere is true for all the other primary forms, for all the primary colors, for all the primary lines; it is just as true for the cube, the sphere, the cylinder, the cone and the pyramid as for the constituent elements of these bodies, the triangle, the square, the circle, as for straight, broken or curved lines, as for obtuse, right, or acute angles, etc.—all the primary elements which react unthinkingly, uniformly, in the same way, on all individuals.

The sensations of a secondary order graft themselves on these primary sensations, producing the intervention of the subject's hereditary or cultural contribution. If brute sensations are of a universal, intrinsic order, secondary sensations are of an individual, extrinsic order. Primary sensations constitute the bases of the plastic language; these are the *fixed words* of the plastic language; it is a fixed, formal, explicit, universal language determining subjective reactions of an individual order which permit the erection on these raw foundations of a sensitive work, rich in emotion.

It does not seem necessary to expatiate at length on this elementary truth that anything of universal value is worth more than anything of merely individual value. It is the condemnation of "individualistic" art to the benefit of "universal" art.

It then becomes clear that to realize this proposed goal it is necessary right now to make an inventory of the plastic vocabulary and to purify it in order to create a transmittable language.

An art that would be based only upon primary sensations, using uniquely primary elements, would be only a primary art, rich, it is true, in geometric aspects, but denuded of all sufficient human resonance: it would be an ornamental art.[2]

An art that would be based only upon the use of secondary sensations (an art of allusions) would be an art without a plastic base.

[2] See *Après le Cubisme,* Ozenfant and Jeanneret, 1918.

The mind of some individuals—only those in intimate resonance with the creator—could be satisfied with it: an art of the initiated, an art requiring knowledge of a key, an art of symbols. This is the critique of most contemporary art; it is this art which, stripped of universal primary elements, has provoked the creation of an immense literature around these works and these schools, a literature whose goal is to explain, to give the key, to reveal the secret language, to permit comprehension.

The great works of the past are those based on primary elements, and this is the only reason why they endure.

Superior sensations of a mathematical order can be born only of a choice of primary elements with secondary resonance.

Having shown that the use of primary elements by themselves can lead only to an ornamental art, we think that to paint means to create constructions: formal and colored organizations based on the theme objects endowed with elementary properties rich in subjective trigger actions. Thus it will be well to chose those theme-objects whose secondary trigger actions are the most universal. The list of these objects would have at its head: man, the beings organized by and the objects fabricated by man, particularly those which one might consider as complements of the human organism.

Man and organized beings are products of *natural selection*. In every evolution on earth, the organs of beings are more and more adapted and purified, and the entire forward march of evolution is a function of purification. The human body seems to be the highest product of natural selection.

When examining these selected forms, one finds a tendency toward certain identical aspects, corresponding to constant functions, functions which are of maximum efficiency, maximum strength, maximum capacity, etc., that is, maximum economy. ECONOMY is the law of natural selection.

It is easy to calculate that it is also the great law which governs what we will call "mechanical selection."

Mechanical selection began with the earliest times and from those times provided objects whose general laws have endured; only the means of making them changed, **the** rules endured.

In all ages and with all people, **man** has created for his use objects of prime necessity which responded to his imperative needs; these objects were associated with his organism and helped complete it. In all ages, for example, man has created containers: vases,

glasses, bottles, plates, which were built to suit the needs of maximum capacity, maximum strength, maximum economy of materials, maximum economy of effort. In all ages, man has created objects of transport: boats, cars; objects of defense: arms; objects of pleasure: musical instruments, etc., all of which have always obeyed the law of selection: economy.

One discovers that all these objects are true extensions of human limbs and are, for this reason, of human scale, harmonizing both among themselves and with man.

The machine was born in the last century. The problem of selection was posed more imperatively than ever (commercial rivalry, cost price); one might say that the machine has led fatally to the strictest respect for, and application of, the laws of economy.

M. Jacques-Emile Blanche will think that these considerations lead us far from painting. On the contrary! It is by the phenomenon of mechanical selection that the forms are established which can almost be called permanent, all interrelated, associated with human scale, containing curves of a mathematical order, curves of the greatest capacity, curves of the greatest strength, curves of the greatest elasticity, etc. These curves obey the laws which govern matter. They lead us quite naturally to satisfactions of a mathematical order.

Modern mechanization would appear to have created objects decidedly remote from what man had hitherto known and practiced. It was believed that he had thus retreated from natural products and entered into an arbitrary order; our epoch decries the misdeeds of mechanization. We must not be mistaken, this is a complete error: the machine has applied with a rigor greater than ever the physical laws of the world's structure. To tell the truth, contemporary poets have only lamented one thing, the peasants' embroidered shirts and the Papuans' tattoos. If blind nature, who produces eggs, were also to make bottles, they would certainly be like those made by the machine born of man's intelligence.

From all this comes a fundamental conclusion: that respect for the laws of physics and of economy has in every age created highly selected objects; that these objects contain analogous mathematical curves with deep resonances; that these artificial objects obey the same laws as the products of natural selection and that, consequently, there thus reigns a total harmony, bringing together the only two things that interest the human being: himself and what he makes.

Both natural selection and mechanical selection are manifestations of purification.

From this it would be easy to conclude that the artist will again find elitist themes in the objects of natural and mechanical selection. As it happens, artists of our period have taken pleasure in ornamental art and have chosen ornamented objects.

A work of art is an association, a symphony of consonant and architectured forms, in architecture and sculpture as well as in painting.

To use as theme anything other than the objects of selection, for example, objects of decorative art, is to introduce a second symphony into the first; it would be redundant, surcharged, it would diminish the intensity and adulterate the quality of the emotion.

Of all recent schools of painting, only Cubism foresaw the advantages of choosing selected objects, and of their inevitable associations. But, by a paradoxical error, instead of sifting out the general laws of these objects, Cubism only showed their accidental aspects, to such an extent that on the basis of this erroneous idea it even re-created arbitrary and fantastic forms. Cubism made square pipes to associate with matchboxes, and triangular bottles to associate with conical glasses.

From this critique and all the foregoing analyses, one comes logically to the necessity of a reform, the necessity of a logical choice of themes, and the necessity of their association not by deformation, but *by formation*.

If the Cubists were mistaken, it is because they did not seek out the invariable constituents of their chosen themes, which could have formed a universal, transmittable language.

Between the chosen theme-object and the plastic organism which the creator's imagination derives from it, there intervenes the necessary labor of total plastic re-creation.

Our concept of the object comes from total knowledge of it, a knowledge acquired by the experience of our senses, tactile knowledge, knowledge of its materials, its volume, its profile, of all its properties. And the usual perspective view only acts as the shutter-release for the memory of these experiences.

Ordinary perspective with its theoretical rigor only gives an accidental view of objects: the one which an eye, having never before seen the object, would see if placed in the precise visual angle of this perspective, always a particular and hence an incomplete angle.

A painting constructed with exact perspective appeals nearly exclusively to sensations of a secondary order and is consequently deprived of what could be universal and durable.

There are, then, good grounds for creating images, organizations of form and color which bear the invariable, fundamental properties of the object-themes. It is by a skillful, synthesizing figuration of these invariable elements that the painter will, upon bases of primary sensations, make his disposition of secondary sensations that are transmittable and universal: the *"Purist"* quest.

The Purist element is like a plastic word duly formed, complete, with precise and universal reactions.

Of course it must not be assumed that Purist elements are like so many stencils that one could juxtapose on the surface of a painting; but we do wish to say that the Purist element, a bottle-element for example, ought always to embody the characteristic and invariant constants of the object-theme, subject to the modifications demanded by the composition.

Purism would never permit a bottle of triangular shape, because a triangular bottle, which eventually could be produced by a glass-blower, is only an exceptional object, a fantasy, like the idea behind it.

Conception

We have already said that the goal of art is to put the spectator in a state of a mathematical quality, that is, a state of an elevated order. To conceive, it is first necessary to know what one wishes to do and to specify the proposed goal; to know if one wishes to settle for pleasing the senses, or if one wishes the painting to be a simple pleasure for the eyes, or to know if one wishes to satisfy the senses and the mind at the same time.

There are obviously those arts whose only ambition is to please the senses; we call them "arts of pleasure." Purism offers an art that is perhaps severe, but one that addresses itself to the elevated faculties of the mind.

This is stated to make it clear that the creator should put himself in a certain state of mind before picking up his paintbrush.

Conception is, in effect, an operation of the mind which foreshadows the general look of the art work.

Possessed of a method whose elements are like the words of a

language, the creator chooses among these words those that he will group together to create a symphony of sensations in the spectator, a symphony that will place the spectator in a state of a particular quality, joy, gaiety, sadness, etc.

Often there is a confusion between conception and composition. These are two entirely different things, conception being a state of mind; composition, a technical means.

Conception is the choice, the decision of which emotion to transmit; composition is the choice of means capable of transmitting this emotion.

Composition

Composition is our stock-in-trade; it involves tasks of an exclusively physical order. Composition comprises choice of surface, division of the surface, co-modulation, relationships of density, color scheme.

A painting is an association of purified, related, and architectured elements.

A painting should not be a fragment, a painting is a whole. A viable organ is a whole: a viable organ is not a fragment.

Space is needed for architectural composition; space means three dimensions. Therefore we think of the painting not as a surface, but *as a space*.

It is customary to choose the format of the painting rather arbitrarily. Many painters unthinkingly adopt very elongated surfaces, fragmentary surfaces which pass beyond the eye's normal field.

Now there is a correlation between the eye's visual cone and the painting it covers.

The eye should be confronted with a space which gives the impression of a whole. A landscape seen through a high window, a bull's-eye or a square window gives a painful impression because it is fragmentary: the window of a sleeping-car offers a satisfying visual field corresponding to normal vision.

If Ingres paper and Whatman paper have a fixed format, and if canvases of 40 x 32, for example, have a format unchanged for so many years, it is because their proportions satisfy physiological needs. These formats correspond to the visual cone and their whole extent can be grasped in a single glance; a natural philosopher would perhaps demonstrate that these slightly oblong proportions

harmonize with the visual cone which is not circular, but slightly oval, and one could' thus explain that vertical paintings are less satisfying than horizontal.

The square format is a particular case resulting in a truncated space. Moreover, it is deprived of one of the fundamental plastic necessities, that of rhythm, precluded by the equal sides.

For physiological reasons we cannot develop here, one could also verify that the vertical line has dynamic properties opposed to the static properties of the horizontal. The eye becomes tired climbing up a vertical, and comes rapidly back down. This explains the dynamic property of the vertical line, contrary to the horizontal which generates feelings of stability, calm, and repose, sensations resulting from the slight energy necessitated by the journey. This explains why surfaces of vertical extent possess properties very different from those of horizontal surfaces.

Moreover, the painter should not concentrate on particular surfaces which necessarily determine sensations of an accidental order. A painting surface should make one forget its limits, it should be *indifferent*.

As for us, we have chosen surfaces similar to the 40 x 32 canvas, considering it to be of an indifferent order of surface.

Further, this surface has important geometric properties; it permits various regulating lines which determine geometric locations of the highest plastic value. These regulating lines are those of the equilateral triangle which neatly fits on a canvas and determines on its axes two *right-angle locations* of the highest constructive value.

The painting is thus divided into segments with like angles and contains lines which lead the eye to the most sensitive points. These sensitive points constitute truly strategic and organic centers of the composition.

This is a capital fact for plastic art because in all ages and times, great works of architecture as well as of painting have been composed by imperious regulating lines of this nature.

Compositions thus endowed, instead of following the caprices of an effervescent imagination, will have generous directives in the subdividing of the painting which will determine its concordances, amplify its resonances, discipline the grouping of its masses, and locate its capital points.

The choice of surface for such geometric determinations has been a preoccupation of every age. Memory of it remains in the famous term *golden section* which haunts studios like the specter of the philosophical stone. The golden section is not a portion of the

surface. It is a mathematical section permitting the division of a straight line so that a harmonious relation reigns between the two segments.

A triangle is constructed on this division called the *golden section triangle*, and this triangle, peddled in cardboard in all the studios, is used as a unifier of angles; it has some benefits, but pushing it about on the painting without a coherent orientation with the format does not realize the plastic condition, which demands that the directive lines of a painting proceed from the geometric properties of the surface.

The old masters used the golden section, as well as others, such as the *harmonic section*, to modulate their works: but they used them as divisions of lines, not of surfaces.

Once the composition is built upon the formal bases of this firm geometry, there is still unity to attain, the factor of order. The *module* comes in at this point.

Unity in plastic art, the homogeneity of the creator's ideas with his means, is the homogeneous relationship of surface or volume with each of the elements brought into play. The modular method is the only sensible way of bringing about order; it lets the smallest element measure the largest (give or take the necessary corrections and optical illusions); it provides what the old masters called proportion.

"Co-modulation" permits organization; without it, there is no plastic art, only piles of stones or spots of color.[3]

Values: Once the composition is solidly built upon directives imposed by the format of the canvas, co-modulated by the intervention of a unifying agent, one must still determine the exact play of densities and the values of light and shade. This play of values is composed of two factors: shadow and light; it creates a rhythm whose relationships shall be dictated by the nature of the feeling to be stimulated.

An analysis of old works shows certain constants in the distribution of density of light and shade, following the intention of the

[3] Cézanne had the habit of saying that he had to *modulate* his canvas. This term has been misinterpreted in our epoch when "sensitivity" holds such a high place. It is not understood that Cézanne, when he spoke of a module, thought of it as would an architect and was seeking to give unity to his formal conceptions; it has been thought that to modulate meant to work musically, to add nuances, to warble. It was a case of form, not of sound.

painting, constants that we have easily shown to exist by a method of weighing (used also in astronomy, but which we have applied to painting).

When one says painting, inevitably he says color. But color has properties of shock (sensory order) which strike the eye before form (which is a creation already cerebral in part).

Now painting is a question of architecture, and therefore volume is its means.

In the expression of volume, color is a perilous agent; often it destroys or disorganizes volume because the intrinsic properties of color are very different, some being radiant and pushing forward, others receding, still others being massive and staying in the real plane of the canvas, etc.; citron yellow, ultramarine blue, earths and vermilions all act very differently, so differently that one can admit without error a certain classification by family.

One can by hierarchy determine the *major scale,* formed of ochre yellows, reds, earths, white, black, ultramarine blue, and, of course, certain of their derivatives; this scale is a strong, stable scale giving unity and holding the plane of the picture since these colors keep one another in balance. They are thus essentially constructive colors; it is these that all the great periods employed; it is these that whoever wishes to paint in volume should use.

Second scale.—The *dynamic scale,* including citron yellow, the oranges (chrome and cadmium), vermilions, Veronese green, light cobalt blues. An essentially animated, agitated scale, giving the sensation of a perpetual change of plane; these colors do not keep to one plane; sometimes they seem in front of the surface plane, sometimes behind. They are the disturbing elements.

Finally there is the *transitional scale,* the madders, emerald green, all the lakes which have properties of tinting, not of construction.

This analysis leads to a formal conclusion; on the use of one or another of these categories, or their intermixing, rest the three great methods of plastic realization which have shared the favor of artists, who pursued different goals according as their esthetic was more or less architectural.

There are in effect two strong, and totally different manners of pictorial expression, either using the exclusive aid of light and shade and uniting all objects by the unique factor of luminous intensity, or else accepting objects in their qualifying color and painting them in this local qualifying hue (local tone). A painting cannot be made without color. Neither Cubism—cameo period of

Picasso among others—nor the Last Judgment in the Sistine Chapel
were able to do without it. The painters resolved this formidable
fatality of color in both cases by harmonizing it with the first great
need of a plastic work, unity. Artists of the first manner mentioned
above, Michelangelo, Rembrandt, El Greco, Delacroix, found har-
mony by judiciously arranging tinted light; the others, Raphael,
Ingres, Fouquet, accepted local qualifiers and attempted to main-
tain the expression of volume, despite the disaggregating force of
color. Thus, with El Greco, the same yellow lightens the edge of an
angel's wing, the knee of a figure, the lines of a face, and the con-
vexities of a cloud; the same madder red colors clothing, ground,
or buildings; the same thing in Renoir's case. With Ingres, as with
Raphael, a figure is in flesh tone, a drapery is blue or red, a pave-
ment is black, brown or white, a sky is blue or grey. As for Cézanne,
who practiced the obstinate and maniacal search for volume with
all the confusion and trouble which animated his being, his work
became monochromatic; all his beautiful, vivid greens,[4] all the
precious vermilions, all the chrome yellows and azure blues of his
palette were in the end broken to such a degree that his painting is
one of the most monochromatic of any period: the paradoxical
activity of an orchestra leader (this latter a really contemporary
figure) who tries to make violin music with an English horn, and
bassoon sounds with a violin.

Finally there are painters of recent times who have mixed the
two manners and who, not possessed of an architectural esthetic,
use indifferently all the families of colors, happy that they produce
a vibrato adjudged pleasant but which in the long run brings their
work back to the esthetic of printed cloth (virtue of dyes).

In summary, in a true and durable plastic work, it is *form* which
comes first and everything else should be subordinated to it. Every-
thing should help establish the architectural achievement. Cé-
zanne's imitators were quite right to see the error of their master,
who accepted without examination the attractive offer of the color-
vendor, in a period marked by a fad for color-chemistry, a science
with no possible effect on great painting.

Let us leave to the clothes-dyers the sensory jubilations of the
paint tube.

As for us, we find that the *major scale* alone furnishes unlimited
richnesses, and that an impression of vermilion can be given not
just sufficiently, but yet more powerfully, by the use of burnt ochre.
In accepting this discipline, we have the certitude of confining color

[4] See *L'Esprit Nouveau*, Number 2, p. 144.

to its hierarchical place; even then, with this carefully picked scale, what discernment it takes to mat the colors!

To conclude the problem of color, it is well to specify certain purely rational investigations which add reassuring certitudes based upon our visual functions, our experience, and our habits. Our mind reacts to colors as it reacts to basic forms. There are brutal colors and suave colors, each appropriate to its object. Moreover, given the play of memory, acquired in looking at nature, logical and organic habits are created in us which confer on each object a qualifying, and hence constructive color; thus blue cannot be used to create a volume that should "come forward," because our eye, accustomed to seeing blue in depths (sky, sea), in backgrounds and in distant objects (horizons), does not permit with impunity the reversing of these conditions. Hence a plane that comes forward can never be blue; it could be green (grass), brown (earth); in summary, colors should be disciplined while taking account of these two incontestable standards:

1. The primary sensory standard, immediate excitation of the senses (red and the bull, black and sadness).

2. The secondary standard of memory, recall of visual experience and of our harmonization of the world (soil is not blue, the sky is not brown, and if sometimes they may seem so, it would only be an accident to be disregarded by an art of invariables).

Sensitivity

At last we come to sensitivity.

Until now, if M. Jacques-Emile Blanche has been willing to follow us, he must have found in all this a good many "platitudes," and little place for exquisite and noble sensitivity.

Until now, we have spoken only of the means of making works of art, because it is there that ideas must command respect. For the question of individual talent, there is really little that can be said; it is a gift of God and not of esthetics. We are here in full harmony of thought with M. J.-E. Blanche: that an art deprived of sensitivity does not exist, and that sensitivity gives life to a work of art. All the same, we affirm that the mind claims imperative rights in what is called a work of art, the work of art being one of the highest manifestations of the human mind. In admitting this postulate, we acknowledge the necessity of architectured painting; we have sought to push aside all factors of futility or disaggregation; we have sought to bring together the constructive means; we have

kept to physical questions and have tried that way to throw out bridges toward mathematical order.

Purism

The highest delectation of the human mind is the perception of order, and the greatest human satisfaction is the feeling of collaboration or participation in this order. The work of art is an artificial object which lets the spectator be placed in the state desired by the creator. The sensation of order is of a mathematical quality. The creation of a work of art should utilize means for specified results. Here is how we have tried to create a language possessing these means:

Primary forms and colors have standard properties (universal properties which permit the creation of a transmittable plastic language). But the utilization of primary forms does not suffice to place the spectator in the sought-for state of mathematical order. For that one must bring to bear the associations of natural or artificial forms, and the criterion for their choice is the degree of selection at which certain elements have arrived (natural selection and mechanical selection). The Purist element issued from the purification of standard forms is not a copy, but a creation whose end is to materialize the object in all its generality and its invariability. Purist elements are thus comparable to words of carefully defined meaning; Purist syntax is the application of constructive and modular means; it is the application of the laws which control pictorial space. A painting is a whole (unity); a painting is an artificial formation which, by appropriate means, should lead to the objectification of an entire "world." One could make an art of allusions, an art of fashion, based upon surprise and the conventions of the initiated. Purism strives for an art free of conventions which will utilize plastic constants and address itself above all to the universal properties of the senses and the mind.

Klee
On Modern Art

Paul Klee's *On Modern Art* was not published until 1945, twenty-one years after it was delivered as a lecture. It has therefore not had such wide currency as the *Pedagogical Sketchbook* of 1925, his most famous writing.

Klee (1879-1940) was a native of Switzerland who came to Munich to study art in 1898, but he seems not to have known Kandinsky although they were both in the Bavarian capital for several years. They finally met in 1911, and Klee joined the second *Blaue Reiter* exhibition the following year. Equally important was his visit with Robert Delaunay in Paris in 1912. Klee translated Delaunay's essay on light for the January 1913 issue of *Der Sturm,* and began to unfold his sense of color which, with his already developed graphic gifts, helped bring him to fame. In 1920 Klee wrote the introspective *Creative Credo (Schöpferische Konfession).* The following year he went to the Bauhaus at Weimar, where he was again associated with Kandinsky. His *Pedagogical Sketchbook* of 1925, like Kandinsky's *Point and Line to Plane* of 1926, was a Bauhaus publication that came directly from his teaching. It is essentially a series of provocative speculations upon the linear diagrams and forms which dominate its pages. In *On Modern Art,* Klee speaks more directly of his esthetic, but not in a metaphysical manner. This genial essay is instead a fusion of sensitive poetry and common sense. It is one of the most beautiful apologias for that modern art which is not entirely abstract, but whose images are at a far remove from those of the accepted, everyday world.

On Modern Art was a lecture to the Jena Kunstverein in

1924. The notes which he used for the lecture—presumably embellished extemporaneously—were first published by the Verlag Benteli, Bern-Bümpliz, in 1945, as *Paul Klee: Über die moderne Kunst*. The first English edition was published by Faber and Faber, London, in 1948 (with subsequent printings) as *Paul Klee: On Modern Art*, translated by Paul Findlay, with a foreword by Sir Herbert Read. This handsome illustrated edition containing twenty-four drawings is still, fortunately, in print. I am indebted to Faber and Faber for permission to reprint the essay here.

On Modern Art

SPEAKING here in the presence of my work, which should really express itself in its own language, I feel a little anxious as to whether I am justified in doing so and whether I shall be able to find the right approach.

For, while as a painter I feel that I have in my possession the means of moving others in the direction in which I myself am driven, I doubt whether I can give the same sure lead by the use of words alone.

But I comfort myself with the thought that my words do not address themselves to you in isolation, but will complement and bring into focus the impressions, perhaps still a little hazy, which you have already received from my pictures.

If I should, in some measure, succeed in giving this lead, I should be content and should feel that I had found the justification which I had required.

FURTHER, in order to avoid the reproach "Don't talk, painter, paint," I shall confine myself largely to throwing some light on those elements of the creative process which, during the growth of a work of art, take place in the subconscious. To my mind, the real justification for the use of words by a painter would be to shift the emphasis by stimulating a new angle of approach; to relieve the formal element of some of the conscious emphasis which is given and place more stress on content.

This is the kind of readjustment which I should find pleasure in making and which might easily tempt me to embark on a dialectical analysis.

But this would mean that I should be following too closely my own inclinations and forgetting the fact that most of you are much more familiar with content than with form. I shall, therefore, not be able to avoid saying something about form.

I shall try to give you a glimpse of the painter's workshop, and I think we shall eventually arrive at some mutual understanding.

For there is bound to be some common ground between layman and artist where a mutual approach is possible and where the artist no longer appears as a being totally apart.

But, as a being, who like you, has been brought, unasked, into this world of variety, and where, like you, he must find his way for better or for worse.

A being who differs from you only in that he is able to master life by the use of his own specific gifts; a being perhaps happier than the man who has no means of creative expression and no chance of release through the creation of form.

This modest advantage should be readily granted the artist. He has difficulties enough in other respects.

May I use a simile, the simile of the tree? The artist has studied this world of variety and has, we may suppose, unobtrusively found his way in it. His sense of direction has brought order into the passing stream of image and experience. This sense of direction in nature and life, this branching and spreading array, I shall compare with the root of the tree.

From the root the sap flows to the artist, flows through him, flows to his eye.

Thus he stands as the trunk of the tree.

Battered and stirred by the strength of the flow, he molds his vision into his work.

As, in full view of the world, the crown of the tree unfolds and spreads in time and in space, so with his work.

Nobody would affirm that the tree grows its crown in the image of its root. Between above and below can be no mirrored reflection. It is obvious that different functions expanding in different elements must produce vital divergences.

But it is just the artist who at times is denied those departures from nature which his art demands. He has even been charged with incompetence and deliberate distortion.

And yet, standing at his appointed place, the trunk of the tree, he does nothing other than gather and pass on what comes to him from the depths. He neither serves nor rules—he transmits.

His position is humble. And the beauty at the crown is not his own. He is merely a channel.

Before starting to discuss the two realms which I have compared with the crown and the root, I must make a few further reservations.

It is not easy to arrive at a conception of a whole which is constructed from parts belonging to different dimensions. And not only nature, but also art, her transformed image, is such a whole.

It is difficult enough, oneself, to survey this whole, whether nature or art, but still more difficult to help another to such a comprehensive view.

This is due to the consecutive nature of the only methods available to us for conveying a clear three-dimensional concept of an image in space, and results from deficiencies of a temporal nature in the spoken word.

For, with such a medium of expression, we lack the means of discussing, in its constituent parts, an image which possesses simultaneously a number of dimensions.

But, in spite of all these difficulties, we must deal with the constituent parts in great detail.

However, with each part, irrespective of the amount of study which it may itself require, we must not lose sight of the fact that it is only a part of the whole. Otherwise our courage may fail us when we find ourselves faced with a new part leading in a completely different direction, into new dimensions, perhaps into a remoteness where the recollection of previously explored dimensions may easily fade.

To each dimension, as, with the flight of time, it disappears from view, we should say: now you are becoming the Past. But possibly later at a critical—perhaps fortunate—moment we may meet again on a new dimension, and once again you may become the Present.

And, if, as the number of dimensions grows, we find increasing difficulty in visualizing all the different parts of the structure at the same time, we must exercise great patience.

What the so-called spatial arts have long succeeded in expressing, what even the time-bound art of music has gloriously achieved in the harmonies of polyphony, this phenomenon of many simultaneous dimensions which helps drama to its climax, does not, unfortunately, occur in the world of verbal didactic expression.

Contact with the dimensions must, of necessity, take place externally to this form of expression; and subsequently.

And yet, perhaps I shall be able to make myself so completely understood that, as a result, you will be in a better position with any given picture, to experience easily and quickly the phenomenon of simultaneous contact with these many dimensions.

As a humble mediator—not to be identified with the crown of the tree—I may well succeed in imparting to you a power of rich, brilliant vision.

And now to the point—the dimensions of the picture.

I HAVE already spoken of the relationship between the root and the crown, between nature and art, and have explained it by a comparison with the difference between the two elements of earth and air, and with the correspondingly differing functions of below and above.

The creation of a work of art—the growth of the crown of the tree —must of necessity, as a result of entering into the specific dimensions of pictorial art, be accompanied by distortion of the natural form. For, therein is nature reborn.

What, then, are these specific dimensions?

First, there are the more or less limited, formal factors, such as line, tone value, and color.

Of these, line is the most limited, being solely a matter of simple Measure. Its properties are length (long or short), angles (obtuse or acute), length of radius and focal distance. All are quantities subject to measurement.

Measure is the characteristic of this element. Where the possibility of measurement is in doubt, line cannot have been handled with absolute purity.

Of a quite different nature is tone value, or, as it is also called, chiaroscuro—the many degrees of shading between black and white. This second element can be characterized by Weight. One stage may be more or less rich in white energy, another more or less weighted toward the black. The various stages can be weighed against one another. Further, the blacks can be related to a white norm (on a white background) and the whites to a black norm (on a blackboard). Or both together can be referred to a medium grey norm.

Thirdly, color, which clearly has quite different characteristics. For it can be neither weighed nor measured. Neither with scales nor with ruler can any difference be detected between two surfaces, one a pure yellow and the other a pure red, of similar area and similar brilliance. And yet, an essential difference remains, which we, in words, label yellow and red.

In the same way, salt and sugar can be compared, in their saltiness and sweetness.

Hence, color may be defined as Quality.

We now have three formal means at our disposal—Measure, Weight, and Quality, which in spite of fundamental differences, have a definite interrelationship.

The form of this relationship will be shown by the following short analysis.

Color is primarily Quality. Secondly, it is also Weight, for it has not only color value but also brilliance. Thirdly, it is Measure, for besides Quality and Weight, it has its limits, its area, and its extent, all of which may be measured.

Tone value is primarily Weight, but in its extent and its boundaries, it is also Measure.

Line, however, is solely Measure.

Thus, we have found three quantities which all intersect in the region of pure color, two only in the region of pure contrast, and only one extends to the region of pure line.

These three quantities impart character, each according to its individual contribution—three interlocked compartments. The largest compartment contains three quantities, the medium two, and the smallest only one.

(Seen from this angle the saying of Liebermann may perhaps be best understood "The art of drawing is the art of omission.")

This shows a remarkable intermixture of our quantities and it is only logical that the same high order should be shown in the clarity with which they are used. It is possible to produce quite enough combinations as it is.

Vagueness in one's work is therefore only permissible when there is a real inner need. A need which could explain the use of colored or very pale lines, or the application of further vagueness such as the shades of grey ranging from yellow to blue.

The symbol of pure line is the linear scale with its wide variations of length.

The symbol of pure contrast is the weight scale with its different degrees between white and black.

What symbol is now suitable for pure color? In what unit can its properties best be expressed?

IN THE completed color circle, which is the form best suited for expressing the data necessary to define the relationship between the colors.

Its clear center, the divisibility of its circumference into six arcs, the picture of the three diameters drawn through these six intersections; in this way the outstanding points are shown in their place against the general backcloth of color-relationships.

These relationships are firstly diametrical and, just as there are three diameters, so are there three diametrical relations worthy of mention, namely Red Green Yellow Purple and Blue Orange (i.e. the principal complementary color-pairs).

Along the circumference the main or primary colors alternate with the most important mixed or secondary colors in such a manner that the mixed colors (three in number) lie between their primary components, i.e. green between yellow and blue, purple between red and blue, and orange between yellow and red.

The complementary color pairs connected by the diameters mutually destroy each other since their mixture along the diameter results in grey. That this is true for all three is shown by the fact that all three diameters possess a common point of intersection and of bisection, the grey center of the color circle.

Further, a triangle can be drawn through the points of the three primary colors, yellow, red, and blue. The corners of this triangle are the primary colors themselves and the sides between each represent the mixture of the two primary colors lying at their extremes. Thus the green side lies opposite the red corner, the purple side opposite the yellow corner, and the orange side opposite the blue corner. There are now three primary and three main secondary colors or six main adjacent colors, or three color pairs.

Leaving this subject of formal elements I now come to the first construction using the three categories of elements which have just been enumerated.

This is the climax of our conscious creative effort.
This is the essence of our craft.
This is critical.

From this point, given mastery of the medium, the structure can be assured foundations of such strength that it is able to reach out into dimensions far removed from conscious endeavor.

This phase of formation has the same critical importance in the negative sense. It is the point where one can miss the greatest and most important aspects of content and thus fail, although possibly possessing the most exquisite talent. For one may simply lose one's bearings on the formal plane. Speaking from my own experience, it depends on the mood of the artist at the time which of the many elements are brought out of their general order, out of their appointed array, to be raised together to a new order and form an image which is normally called the subject.

This choice of formal elements and the form of their mutual relationship is, within narrow limits, analogous to the idea of motif and theme in musical thought.

With the gradual growth of such an image before the eyes an association of ideas gradually insinuates itself which may tempt one to a material interpretation. For any image of complex structure can, with some effort of imagination, be compared with familiar pictures from nature.

These associative properties of the structure, once exposed and labelled, no longer correspond wholly to the direct will of the artist (at least not to his most intensive will) and just these associative properties have been the source of passionate misunderstandings between artist and layman.

While the artist is still exerting all his efforts to group the formal elements purely and logically so that each in its place is right and none clashes with the other, a layman, watching from behind, pronounces the devastating words "But that isn't a bit like uncle."

The artist, if his nerve is disciplined, thinks to himself, "To hell with uncle! I must get on with my building. . . . This new brick is a little too heavy and to my mind puts too much weight on the left; I must add a good-sized counterweight on the right to restore the equilibrium."

And he adds this side and that until finally the scales show a balance.

And he is relieved if, in the end, the shaking which he has perforce had to give his original pure structure of good elements, has only gone so far as to provide that opposition which exists as contrast in a living picture.

But sooner or later, the association of ideas may of itself occur to him, without the intervention of a layman. Nothing need then prevent him from accepting it, provided that it introduces itself under its proper title.

Acceptance of this material association may suggest additions which, once the subject is formulated, clearly stand in essential relationship to it. If the artist is fortunate, these natural forms may fit into a slight gap in the formal composition, as though they had always belonged there.

The argument is therefore concerned less with the question of the existence of an object, than with its appearance at any given moment—with its nature.

I only hope that the layman who, in a picture, always looks for his favorite subject, will, as far as I am concerned, gradually die out and remain to me nothing but a ghost which cannot help its failings. For a man only knows his own objective passions. And admittedly it gives him great pleasure when, by chance, a familiar face of its own accord emerges from a picture.

The objects in pictures look out at us serene or severe, tense or relaxed, comforting or forbidding, suffering or smiling.

They show us all the contrasts in the psychic-physiognomical field, contrasts which may range from tragedy to comedy.

But it is far from ending there.

The figures, as I have often called these objective images, also have their own distinctive aspects, which result from the way in which the selected groups of elements have been put in motion.

If a calm and rigid aspect has been achieved, then the construction has aimed at giving either an array along wide horizontals without any elevation, or, with high elevation, prominence to visible and extended verticals.

This aspect can, while preserving its calm, lose some of its rigidity. The whole action can be transferred to an intermediate state such as water or atmosphere, where no predominant verticals exist (as in floating or hovering).

I say intermediate state as distinct from the first wholly earthbound position.

At the next stage a new aspect appears. Its character, which is one of extreme turbulence, has the effect of giving it life.

Why not?

I have admitted that, in a picture, an objective concept can be justified and have thus acquired a new dimension.

I have named the elements of form singly and in their particular context.

I have tried to explain their emergence from this context.

I have tried to explain their appearance as groups, and their combination, limited at first, but later somewhat more extensive, into images.

Into images which, in the abstract, may be called constructions, but which, seen concretely, may be named each after the association which they have prompted, such as star, vase, plant, animal, head, or man.

This, firstly, identified the dimensions of the elemental ingredients of the picture with line, tone value, and color. And then the first constructive combination of these ingredients gave us the dimension of figure or, if you prefer it, the dimension of object.

THESE dimensions are now joined by a further dimension which determines the question of content.

Certain proportions of line, the combination of certain tones from the scale of tone values, certain harmonies of color, carry with them at the time quite distinctive and outstanding modes of expression.

The linear proportions can, for example, refer to angles: movements which are angular and zigzag—as opposed to smooth and horizontal—strike resonances of expression which are similarly contrasting.

In the same way a conception of contrast can be given by two forms of linear construction, the one consisting of a firmly jointed structure and the other of lines loosely scattered.

Contrasting modes of expression in the region of tone value are given by:

The wide use of all tones from black to white, implying full-bodied strength.

Or the limited use of the upper light half or the lower dark half of the scale.

Or medium shades around the grey which imply weakness through too much or too little light.

Or timid shadows from the middle. These, again, show great contrasts in meaning.

And what tremendous possibilities for the variation of meaning are offered by the combination of colors.

Color as tone value: e.g. red in red, i.e. the entire range from a deficiency to an excess of red, either widely extended, or limited in range. Then the same in yellow (something quite different). The same in blue—what contrasts!

Or colors diametrically opposed—i.e. changes from red to green, from yellow to purple, from blue to orange.

Tremendous fragments of meaning.

Or changes of color in the direction of chords,[1] not touching the grey center, but meeting in a region of warmer or cooler grey.

What subtleties of shading compared with the former contrasts.

Or: color changes in the direction of arcs of the circle, from yellow through orange to red or from red through violet to blue, or far flung over the whole circumference.

What tremendous variations from the smallest shading to the glowing symphony of color. What perspectives in the dimension of meaning!

Or finally, journeys through the whole field of color, including the grey center, and even touching the scale from black to white.

ONLY on a new dimension can one go beyond these last possibilities. We could now consider what is the proper place for the assorted colors, for each assortment clearly possesses its possibilities of combination.

And each formation, each combination will have its own particular constructive expression, each figure its face—its features.

Such forceful means of expression point quite clearly to the dimension of style. Here Romanticism arose in its crassly pathetic phase.

This form of expression tries convulsively to fly from the earth and eventually rises above it to reality. Its own power forces it up, triumphing over gravity.

If, finally, I may be allowed to pursue these forces, so hostile to earth, until they embrace the life force itself, I will emerge from the oppressively pathetic style to that Romanticism which is one with the universe.

Thus, the statics and dynamics of the mechanism of creative art coincide beautifully with the contrast between Classicism and Romanticism.

[1 The word used by the author was "segment." This would appear to be a geometrical slip which has been corrected in the translation.—Translator's note.]

Our picture has, as has been described, progressed gradually through dimensions so numerous and of such importance, that it would be unjust to refer to it any longer as a "Construction." From now on we will give it the resounding title of "Composition."

On the subject of the dimensions, however, let us be content with this rich perspective.

I WOULD like now to examine the dimensions of the object in a new light and so try to show how it is that the artist frequently arrives at what appears to be such an arbitrary "deformation" of natural forms.

First, he does not attach such intense importance to natural form as do so many realist critics, because, for him, these final forms are not the real stuff of the process of natural creation. For he places more value on the powers which do the forming than on the final forms themselves.

He is, perhaps unintentionally, a philosopher, and if he does not, with the optimists, hold this world to be the best of all possible worlds, nor to be so bad that it is unfit to serve as a model, yet he says:

"In its present shape it is not the only possible world."

Thus he surveys with penetrating eye the finished forms which nature places before him.

The deeper he looks, the more readily he can extend his view from the present to the past, the more deeply he is impressed by the one essential image of creation itself, as Genesis, rather than by the image of nature, the finished product.

Then he permits himself the thought that the process of creation can today hardly be complete and he sees the act of world creation stretching from the past to the future. Genesis eternal!

He goes still further!

He says to himself, thinking of life around him: this world at one time looked different and, in the future, will look different again.

Then, flying off to the infinite, he thinks: it is very probable that,
on other stars, creation has produced a completely different result.

Such mobility of thought on the process of natural creation is good
training for creative work.

It has the power to move the artist fundamentally, and since he is
himself mobile, he may be relied upon to maintain freedom of
development of his own creative methods.

This being so, the artist must be forgiven if he regards the present
state of outward appearances in his own particular world as acci-
dentally fixed in time and space. And as altogether inadequate
compared with his penetrating vision and intense depth of feeling.

And is it not true that even the small step of a glimpse through
the microscope reveals to us images which we should deem fantastic
and overimaginative if we were to see them somewhere accidentally,
and lacked the sense to understand them?

Your realist, however, coming across such an illustration in a sen-
sational magazine, would exclaim in great indignation: "Is that
supposed to be nature? I call it bad drawing."

Does then the artist concern himself with microscopy? History?
Paleontology?

Only for purposes of comparison, only in the exercise of his mobil-
ity of mind. And not to provide a scientific check on the truth of
nature.

Only in the sense of freedom.
In the sense of a freedom, which does not lead to fixed phases of
development, representing exactly what nature once was, or will be,
or could be on another star (as perhaps may one day be proved).

But in the sense of a freedom which merely demands its rights,
the right to develop, as great Nature herself develops.

From type to prototype.

Presumptuous is the artist who does not follow his road through to the end. But chosen are those artists who penetrate to the region of that secret place where primeval power nurtures all evolution.

There, where the powerhouse of all time and space—call it brain or heart of creation—activates every function; who is the artist who would not dwell there?

In the womb of nature, at the source of creation, where the secret key to all lies guarded.

But not all can enter. Each should follow where the pulse of his own heart leads.

So, in their time, the Impressionists—our opposites of yesterday—had every right to dwell within the matted undergrowth of everyday vision.

But our pounding heart drives us down, deep down to the source of all.

What springs from this source—whatever it may be called, dream, idea or fantasy—must be taken seriously only if it unites with the proper creative means to form a work of art.

Then those curiosities become realities—realities of art which help to lift life out of its mediocrity.

For not only do they, to some extent, add more spirit to the seen, but they also make secret visions visible.

I SAID "with the proper creative means." For at this stage is decided whether pictures or something different will be born. At this stage, also, is decided the kind of the pictures.

These unsettled times have brought chaos and confusion (or so it seems, if we are not too near to judge).

But among artists, even among the youngest of them, one urge seems to be gradually gaining ground:
The urge to the culture of these creative means, to their pure cultivation, to their pure use.

The legend of the childishness of my drawing must have originated from those linear compositions of mine in which I tried to combine a concrete image, say that of a man, with the pure representation of the linear element.

Had I wished to present the man "as he is," then I should have had to use such a bewildering confusion of line that pure elementary representation would have been out of the question. The result would have been vagueness beyond recognition.

And anyway, I do not wish to represent the man as he is, but only as he might be.

And thus I could arrive at a happy association between my vision of life [*Weltanschauung*] and pure artistic craftsmanship.

And so it is over the whole field of use of the formal means: in all things, even in colors, must all trace of vagueness be avoided.

This then is what is called the untrue coloring in modern art.

As you can see from this example of "childishness" I concern myself with work on the partial processes of art. I am also a draughtsman.

I have tried pure drawing, I have tried painting in pure tone values. In color, I have tried all partial methods to which I have been led by my sense of direction in the color circle. As a result, I have worked out methods of painting in colored tone values, in complementary colors, in multicolors and methods of total color painting.

Always combined with the more subconscious dimensions of the picture.

Then I tried all possible syntheses of two methods. Combining and again combining, but, of course, always preserving the culture of the pure element.

Sometimes I dream of a work of really great breadth, ranging through the whole region of element, object, meaning, and style.

This, I fear, will remain a dream, but it is a good thing even now to bear the possibility occasionally in mind.

Nothing can be rushed. It must grow, it should grow of itself, and if the time ever comes for that work—then so much the better!

We must go on seeking it!
We have found parts, but not the whole!
We still lack the ultimate power, for:
the people are not with us.

But we seek a people. We began over there in the Bauhaus. We began there with a community to which each one of us gave what he had.
More we cannot do.

Malevich
Suprematism

Suprematism is the second of the two essays which together comprise *The Non-Objective World*, Malevich's major treatise published in Germany in 1927.

By 1912, Kasimir Malevich (1878-1935) had absorbed the impulses emanating from western Europe and was already an artist of distinction. In 1913 he formulated Suprematism and exhibited his first "Suprematist Element," a square penciled in black on a white background. In the years of revolution after the war, Malevich was a leading force among the Moscow artists devoted to complete abstraction: Rodchenko, Tatlin, and others, including the young brothers recently returned, Gabo and Pevsner. He was named Professor at the Moscow State Art School in 1919 and continued to have a major role until about 1922, when abstract art was no longer palatable to the Party. The growing insistence upon art of immediate social use forced Gabo, Pevsner, Chagall, Kandinsky and Lissitsky to forsake Russia for western Europe. Malevich remained in Russia, but without making a pact with the antirevolutionary esthetic of the post-Lenin Party. He seems to have continued his art in isolation until his death in 1935, with the notable exception of the trip to Germany in 1927.

Malevich came to Berlin in 1927 for an exhibition of his paintings at the *Grosse Berliner Kunstausstellung*. He brought with him the manuscript of his *The Non-Objective World*, which was translated into German by A. von Riesen and published by Albert Langen, Munich, as volume eleven of the Bauhaus books. *Die Gegenstandslose Welt* was presumably written over a span of years. It speaks with Male-

vich's own voice, and yet suits the orientation of the *de Stijl*, Purist, and other movements of the 1920s which shared a faith in the world of modern technology in opposition to Dada and Surrealism.

I have included the second part of the treatise (the first is called "Introduction to the Theory of the Additional Element in Painting") because it is the clearest exposition of his ideas. The first part is actually an application of the principles enunciated in the second, and though ideally both should be read together, it was essential in this anthology to find the text that most completely exposed Malevich's esthetic principles.

The entire text was translated by Howard Dearstyne from the German (the Russian manuscript has not been uncovered) and, accompanied by many illustrations and an introduction by L. Hilbersheimer, was published by Paul Theobald and Company, Chicago, in 1959. It is still in print and should be consulted by the reader who wishes to go beyond this selection. I owe a debt of gratitude to Paul Theobald and Company for authorizing me to reproduce *Suprematism*.

Suprematism

Under Suprematism I understand the supremacy of pure feeling in creative art.

To the Suprematist the visual phenomena of the objective world are, in themselves, meaningless; the significant thing is feeling, as such, quite apart from the environment in which it is called forth.

The so-called "materialization" of a feeling in the conscious mind really means a materialization of the *reflection* of that feeling through the medium of some realistic conception. Such a realistic conception is without value in suprematist art. . . . And not only in suprematist art but in art generally, because the enduring, true value of a work of art (to whatever school it may belong) resides solely in the feeling expressed.

Academic naturalism, the naturalism of the Impressionists, Cézanneism, Cubism, etc.—all these, in a way, are nothing more than dialectic methods which, as such, in no sense determine the true value of an art work.

An objective representation, having objectivity as its aim, is

something which, as such, has nothing to do with art, and yet the use of objective forms in an art work does not preclude the possibility of its being of high artistic value.

Hence, to the Suprematist, the appropriate means of representation is always the one which gives fullest possible expression to feeling as such and which ignores the familiar appearance of objects.

Objectivity, in itself, is meaningless to him; the concepts of the conscious mind are worthless.

Feeling is the determining factor . . . and thus art arrives at non-objective representation—at Suprematism.

It reaches a "desert" in which nothing can be perceived but feeling.

Everything which determined the objective-ideal structure of life and of "art"—ideas, concepts, and images—all this the artist has cast aside in order to heed pure feeling.

The art of the past which stood, at least ostensibly, in the service of religion and the state, will take on new life in the pure (unapplied) art of *Suprematism,* which will build up a new world—the world of feeling. . . .

When, in the year 1913, in my desperate attempt to free art from the ballast of objectivity, I took refuge in the square form and exhibited a picture which consisted of nothing more than a black square on a white field, the critics and, along with them, the public sighed, "Everything which we loved is lost. We are in a desert. . . . Before us is nothing but a black square on a white background!"

"Withering" words were sought to drive off the symbol of the "desert" so that one might behold on the "dead square" the beloved likeness of "reality" ("true objectivity" and a spiritual feeling).

The square seemed incomprehensible and dangerous to the critics and the public . . . and this, of course, was to be expected.

The ascent to the heights of non-objective art is arduous and painful . . . but it is nevertheless rewarding. The familiar recedes ever further and further into the background. . . . The contours of the objective world fade more and more and so it goes, step by step, until finally the world—"everything we loved and by which we have lived"—becomes lost to sight.

No more "likeness of reality," no idealistic images—nothing but a desert!

But this desert is filled with the spirit of non-objective sensation which pervades everything.

Even I was gripped by a kind of timidity bordering on fear when it came to leaving "the world of will and idea," in which I had lived and worked and in the reality of which I had believed.

But a blissful sense of liberating non-objectivity drew me forth into the "desert," where nothing is real except feeling . . . and so feeling became the substance of my life.

This was no "empty square" which I had exhibited but rather the feeling of non-objectivity.

I realized that the "thing" and the "concept" were substituted for feeling and understood the falsity of the world of will and idea.

Is a milk bottle, then, the symbol of milk?

Suprematism is the rediscovery of pure art which, in the course of time, had become obscured by the accumulation of "things."

It appears to me that, for the critics and the public, the painting of Raphael, Rubens, Rembrandt, etc., has become nothing more than a *conglomeration* of countless "things," which conceal its true value—the feeling which gave rise to it. The virtuosity of the objective representation is the only thing admired.

If it were possible to extract from the works of the great masters the feeling expressed in them—the actual artistic value, that is—and to hide this away, the public, along with the critics and the art scholars, would never even miss it.

So it is not at all strange that my square seemed empty to the public.

If one insists on judging an art work on the basis of the virtuosity of the objective representation—the verisimilitude of the illusion —and thinks he sees in the objective representation itself a symbol of the inducing emotion, he will never partake of the gladdening content of a work of art.

The general public is still convinced today that art is bound to perish if it gives up the imitation of "dearly-loved reality" and so it observes with dismay how the hated element of pure feeling— abstraction—makes more and more headway. . . .

Art no longer cares to serve the state and religion, it no longer wishes to illustrate the history of manners, it wants to have nothing further to do with the object, as such, and believes that it can exist, in and for itself, without "things" (that is, the "time-tested well-spring of life").

But the nature and meaning of artistic creation continue to be misunderstood, as does the nature of creative work in general, because feeling, after all, is always and everywhere the one and only source of every creation.

The emotions which are kindled in the human being are stronger than the human being himself . . . they must at all costs find an outlet—they must take on overt form—they must be communicated or put to work.

It was nothing other than a yearning for speed . . . for flight . . . which, seeking an outward shape, brought about the birth of the airplane. For the airplane was not contrived in order to carry business letters from Berlin to Moscow, but in obedience to the irresistible drive of this yearning for speed to take on external form.

The "hungry stomach" and the intellect which serves this must always have the last word, of course, when it comes to determining the origin and purpose of *existing* values . . . but that is a subject in itself.

And the state of affairs is exactly the same in art as in creative technology. . . . In painting (I mean here, naturally, the accepted "artistic" painting) one can discover behind a technically correct portrait of Mr. Miller or an ingenious representation of the flower girl at Potsdamer Platz not a trace of the true essence of art—no evidence whatever of feeling. Painting is the dictatorship of a method of representation, the purpose of which is to depict Mr. Miller, his environment and his ideas.

The black square on the white field was the first form in which non-objective feeling came to be expressed. The square = feeling, the white field = the void beyond this feeling.

Yet the general public saw in the non-objectivity of the representation the demise of art and failed to grasp the evident fact that feeling had here assumed external form.

The suprematist square and the forms proceeding out of it can be likened to the primitive marks (symbols) of aboriginal man which represented, in their combinations, *not ornament but a feeling of rhythm.*

Suprematism did not bring into being a new world of feeling but rather, an altogether new and direct form of representation of the world of feeling.

The square changes and creates new forms, the elements of which can be classified in one way or another depending upon the feeling which gave rise to them.

When we examine an antique column, we are no longer interested in the fitness of its construction to perform its technical task in the building but recognize in it the material expression of a

pure feeling. We no longer see in it a structural necessity but view it as a work of art in its own right.

"Practical life," like a homeless vagabond, forces its way into every artistic form and believes itself to be the genesis and reason for existence of this form. But the vagabond doesn't tarry long in one place and once he is gone (when to make an art work serve "practical purposes" no longer seems practical) the work recovers its full value.

Antique works of art are kept in museums and carefully guarded, not to preserve them for practical use but in order that their eternal artistry may be enjoyed.

The difference between the new, non-objective ("useless") art and the art of the past lies in the fact that the full artistic value of the latter comes to light (becomes recognized) only after life, in search of some new expedient, has forsaken it, whereas the unapplied artistic element of the new art outstrips life and shuts the door on "practical utility."

And so there the new non-objective art stands—the expression of pure feeling, seeking no practical values, no ideas, no "promised land."

An antique temple is not beautiful because it once served as the haven of a certain social order or of the religion associated with this, but rather because its form sprang from a pure feeling for plastic relationships. The artistic feeling which was given material expression in the building of the temple is for us eternally valid and vital but as for the social order which once encompassed it— this is dead.

Life and its manifestations have hitherto been considered from two different standpoints—the material and the religious. It would seem that a consideration of life from the standpoint of art ought to become a third and equally valid point of view. But in practice, art (as a second-rate power) is relegated to the service of those who view the world and life from one or the other of the first two stand-points. This state of affairs is curiously inconsistent with the fact that art always and under all circumstances plays the decisive role in the creative life and that art values alone are absolute and endure forever. With the most primitive of means (charcoal, hog bristles, modeling sticks, catgut, and steel strings) the artist creates something which the most ingenious and efficient technology will never be able to create.

The adherents of "utility" think they have the right to regard art as the apotheosis of life (the utilitarian life, that is).

In the midst of this apotheosis stands "Mr. Miller"—or rather, the portrait of Mr. Miller (that is, a copy of a "copy" of life).

The mask of life hides the true countenance of art. Art is not to us what it could be.

And moreover, the efficiently mechanized world could truly serve a purpose if only it would see to it that we (every one of us) gained the greatest possible amount of "free time" to enable us to meet the only obligation to nature which mankind has taken upon itself—namely to create art.

Those who promote the construction of useful things, things which serve a purpose, and who combat art or seek to enslave it, should bear in mind the fact that there is no such thing as a constructed object which is useful. Has the experience of centuries not demonstrated that "useful" things don't long remain useful?

Every object which we see in the museums clearly supports the fact that not one single, solitary thing is really useful, that is, convenient, for otherwise it would not be in a museum! And if it once seemed useful this is only because nothing more useful was then known. . . .

Do we have the slightest reason to assume that the things which appear useful and convenient to us today will not be obsolete tomorrow . . . ? And shouldn't it give us pause that the oldest works of art are as impressive today in their beauty and spontaneity as they were many thousands of years ago?

The Suprematists have deliberately given up objective representation of their surroundings in order to reach the summit of the true "unmasked" art and from this vantage point to view life through the prism of pure artistic feeling.

Nothing in the objective world is as "secure and unshakeable" as it appears to our conscious minds. We should accept nothing as predetermined—as constituted for eternity. Every "firmly established," familiar thing can be shifted about and brought under a new and, primarily, unfamiliar order. Why then should it not be possible to bring about an artistic order?

The various complementary and conflicting feelings—or rather, images and ideas—which, as reflections of these feelings, take shape in our imaginations, struggle incessantly with each other: the awareness of God against that of the Devil; the sensation of hunger versus a feeling for the beautiful.

The awareness of God strives to vanquish the awareness of the Devil—and the flesh at the same time. It tries to "make credible" the evanescence of earthly goods and the everlasting glory of God.

And art, too, is condemned, except when it serves the worship of God—the Church. . . .

—Out of the awareness of God arose religion—and out of religion the Church.

—Out of the sensation of hunger developed concepts of utility—and out of these concepts trade and industry.

Both the Church and industry tried to monopolize those artistic abilities which, being creative, are constantly finding expression, in order to provide effective bait for their products (for the ideal-material as well as for the purely material). In this way, as the saying goes, "the pill of utility is sugar-coated."

The aggregated reflections of feelings in the individual's consciousness—feelings of the most varied kinds—determine his "view of life." Since the feelings affecting him change, the most remarkable alterations in this "view of life" can be observed; the atheist becomes pious, the God-fearing, godless, etc. . . . The human being can be likened, in a way, to a radio receiver which picks up and converts a whole series of different waves of feeling, the sum-total of which determines the above-mentioned view of life.

Judgments concerning the values of life therefore fluctuate widely. Only art values defy the shifting drift of opinion, so that, for example, pictures of God or the saints, insofar as the artistic feeling incorporated in them is apparent, can be placed by atheists in their collections without compunction (and, in fact, actually are collected by them). Thus do we have, again and again, the opportunity of convincing ourselves that the guidance of our conscious minds—"creation" with a purpose—always calls into being relative values (which is to say, valueless "values") and that nothing but the expression of the pure feeling of the subconscious or superconscious (nothing, that is, other than artistic creation) can give tangible form to absolute values. Actual utility (in the higher sense of the term) could therefore be achieved only if the subconscious or superconscious were accorded the privilege of directing creation.

Our life is a theater piece, in which non-objective feeling is portrayed by objective imagery.

A bishop is nothing but an actor who seeks with words and gestures, on an appropriately "dressed" stage, to convey a religious feeling, or rather the reflection of a feeling in religious form. The office clerk, the blacksmith, the soldier, the accountant, the general . . .

these are all characters out of one stage play or another, portrayed
by various people, who become so carried away that they confuse
the play and their parts in it with life itself. We almost never get to
see the *actual human face* and if we ask someone who he is, he
answers, "an engineer," "a farmer," etc., or, in other words, he gives
the title of the role played ·by him in one or another affective
drama.

The title of the role is also set down next to his full name, and
certified in his passport, thus removing any doubt concerning the
surprising fact that the owner of the passport is the engineer Ivan
and not the painter Kasimir.

In the last analysis, what each individual knows about himself is
precious little, because the "actual human face" cannot be dis-
cerned behind the mask, which is mistaken for the "actual face."

The philosophy of Suprematism has every reason to view both the
mask and the "actual face" with skepticism, since it disputes the
reality of human faces (human forms) altogether.

Artists have always been partial to the use of the human face in
their representations, for they have seen in it (the versatile, mobile,
expressive mimic) the best vehicle with which to convey their feel-
ings. The Suprematists have nevertheless abandoned the representa-
tion of the human face (and of natural objects in general) and have
found new symbols with which to render direct feelings (rather
than externalized reflections of feelings), for *the Suprematist does
not observe and does not touch—he feels.*

We have seen how art, at the turn of the century, divested itself
of the ballast of religious and political ideas which had been im-
posed upon it and came into its own—attained, that is, the form
suited to its intrinsic nature and became, along with the two already
mentioned, a third independent and equally valid "point of view."
The public is still, indeed, as much convinced as ever that the artist
creates superfluous, impractical things. It never considers that these
superfluous things endure and retain their vitality for thousands of
years, whereas necessary, practical things survive only briefly.

It does not dawn on the public that it fails to recognize the real,
true value of things. This is also the reason for the chronic failure
of everything utilitarian. A true, absolute order in human society
could only be achieved if mankind were willing to base this order
on lasting values. Obviously, then, the artistic factor would have to
be accepted in every respect as the decisive one. As long as this is
not the case, the uncertainty of a "provisional order" will obtain,

instead of the longed-for tranquillity of an absolute order, because the provisional order is gauged by current utilitarian understanding and this measuring-stick is variable in the highest degree.

In the light of this, all art works which, at present, are a part of "practical life" or to which practical life has laid claim, are in some sense devaluated. Only when they are freed from the encumbrance of practical utility (that is, when they are placed in museums) will their truly artistic, absolute value be recognized.

The sensations of sitting, standing, or running are, first and foremost, plastic sensations and they are responsible for the development of corresponding "objects of use" and largely determine their form.

A chair, bed, and table are not matters of utility but rather, the forms taken by plastic sensations, so the generally held view that all objects of daily use result from practical considerations is based upon false premises.

We have ample opportunity to become convinced that we are never in a position for recognizing any real utility in things and that we shall never succeed in constructing a really practical object. We can evidently only *feel* the essence of absolute utility but, since a feeling is always non-objective, any attempt to grasp the utility of the objective is Utopian. The endeavor to confine feeling within concepts of the conscious mind or, indeed, to replace it with conscious concepts and to give it concrete, utilitarian form, has resulted in the development of all those useless, "practical things" which become ridiculous in no time at all.

It cannot be stressed too often that absolute, true values arise only from artistic, subconscious, or superconscious creation.

The new art of Suprematism, which has produced new forms and form relationships by giving external expression to pictorial feeling, will become a new architecture: it will transfer these forms from the surface of canvas to space.

The suprematist element, whether in painting or in architecture, is free of every tendency which is social or otherwise materialistic.

Every social idea, however great and important it may be, stems from the sensation of hunger; every art work, regardless of how small and insignificant it may seem, originates in pictorial or plastic feeling. It is high time for us to realize that the problems of art lie far apart from those of the stomach or the intellect.

Now that art, thanks to Suprematism, has come into its own—

that is, attained its pure, unapplied form—and has recognized the infallibility of non-objective feeling, it is attempting to set up a genuine world order, a new philosophy of life. It recognizes the non-objectivity of the world and is no longer concerned with providing illustrations of the history of manners.

Non-objective feeling has, in fact, always been the only possible source of art, so that in this respect Suprematism is contributing nothing new but nevertheless the art of the past, because of its use of objective subject matter, harbored unintentionally a whole series of feelings which were alien to it.

But a tree remains a tree even when an owl builds a nest in a hollow of it.

Suprematism has opened up new possibilities to creative art, since *by virtue of the abandonment of so-called "practical considerations," a plastic feeling rendered on canvas can be carried over into space.* The artist (the painter) is no longer bound to the canvas (the picture plane) and can transfer his compositions from canvas to space.

Gabo

The Constructive Idea in Art

With J. L. Martin and Ben Nicholson, Naum Gabo edited the collection *Circle* in 1937, one of the most fertile gatherings of essays in the twentieth century. Among its contributors were Moholy-Nagy, Massine, Gropius, and Mondrian (whose essay is included in the present anthology). Gabo's *The Constructive Idea in Art* was deservedly the first article in the book.

In 1909, Gabo (born 1890) had been sent to Munich by his father, a Russian businessman, to study medicine. He was more attracted to mathematics, physics, and chemistry, and also became enamored of the arts, a natural result in the Munich of Kandinsky, Klee, and de Chirico. Visits in 1913 and 1914 to his brother Antoine Pevsner, then working in Paris, helped consummate his turning to art. After spending the war years in Oslo, Gabo returned to Moscow and with his brother joined in the movement called Constructivism. Together they wrote its principal statement of the revolutionary years, the "Realistic Manifesto" of 1920. By 1922 the reactionary esthetic of the Party so discouraged Gabo that he left for western Europe. He worked in Germany, France, and England, then came to the United States in 1946.

The *Circle* essay speaks not only for Gabo and Constructivism, but is one of the most sensible statements of the relationships between modern abstract art and science. In the epigrammatic "Science teaches, Art asserts; Science

persuades, Art acts," Gabo points to the independence of art which too often is assimilated with the "scientific attitude," yet he does it from the standpoint of respect and deep love for the sciences.

Naum Gabo kindly extended permission to reproduce his essay here, as did Faber and Faber, London, who published *Circle* in 1937. Among Gabo's important writings are the A. W. Mellon lectures, *Of divers arts* (New York, 1962).

The Constructive Idea in Art

Our century appears in history under the sign of revolution and disintegration. The revolutions have spared nothing in the edifice of culture which had been built up by the past ages. They had already begun at the end of the last century and proceeded in ours with unusual speed until there was no stable point left in either the material or the ideal structure of our life. The war was only a natural consequence of a disintegration which started long ago in the depths of the previous civilization. It is innocent to hope that this process of disintegration will stop at the time and in the place where we want it to. Historical processes of this kind generally go their own way. They are more like floods, which do not depend on the strokes of the oarsmen floating on the waters. But, however long and however deep this process may go in its material destruction, it cannot deprive us any more of our optimism about the final outcome, since we see that in the realm of ideas we are now entering on the period of reconstruction.

We can find efficient support for our optimism in those two domains of our culture where the revolution has been the most thorough, namely, in Science and in Art. The critical analysis in natural science with which the last century ended had gone so far that at times the scientists felt themselves to be in a state of suspension, having lost most of the fundamental bases on which they had depended for so many centuries. Scientific thought suddenly found itself confronted with conclusions which had before seemed impossible, in fact the word "impossibility" disappeared from the lexicon of scientific language. This brought the scientists of our century to the urgent task of filling up this emptiness. This task now occupies the main place in all contemporary scientific works. It consists in the construction of a new stable model for our apprehension of the universe.

However dangerous it may be to make far-reaching analogies between Art and Science, we nevertheless cannot close our eyes to the fact that at those moments in the history of culture when the creative human genius had to make a decision, the forms in which this genius manifested itself in Art and in Science were analogous. One is inclined to think that this manifestation in the history of Art lies on a lower level than it does in the history of Science, or at least on a level which is accessible to wider social control. The terminology of Science alone plunges a layman into a state of fear, humility, and admiration. The inner world of Science is closed to an outsider by a curtain of enigmas. He has been educated to accept the holy mysticism of these enigmas since the beginning of culture. He does not even try to intrude in this world in order to know what happens there, being convinced that it must be something very important since he sees the results in obvious technical achievements. The average man knows, for instance, that there is electricity and that there is radio and he uses them every day. He knows the names of Marconi and Edison, but it is doubtful whether he has ever heard anything about the scientific work of Hertz, and there is no doubt that he has never heard anything about the electromagnetic waves theory of Maxwell or his mathematical formulae.

Not so is the attitude of the average man to Art. Access to the realm of Art is open to every man. He judges about Art with the unconstrained ease of an employer and owner. He does not meditate about those processes which brought the artist or the group of artists to make one special kind of Art and not another, or if occasionally he does he never relinquishes his right to judge and decide, to accept or reject; in a word, he takes up an attitude which he would never allow himself to take with Science. He is convinced that on his judgments depend the value and the existence of the work of art. He does not suspect that through the mere fact of its existence a work of art has already performed the function for which it has been made and has affected his concept of the world regardless of whether he wants it to or not. The creative processes in the domain of Art are as sovereign as the creative processes in Science. Even for many theorists of Art the fact remains unperceived that the same spiritual state propels artistic and scientific activity at the same time and in the same direction.

At first sight it seems unlikely that an analogy can be drawn between a scientific work of, say, Copernicus and a picture by Raphael, and yet it is not difficult to discover the tie between them. In fact Copernicus' scientific theory of the world is coincident

with Raphael's concept in Art. Raphael would never have dared to take the naturalistic image of his famous Florentine pastry-cook as a model for the "Holy Marie" if he had not belonged to the generation which was already prepared to abandon the geocentrical theory of the universe. In the artistic concept of Raphael there is no longer any trace of the mythological religious mysticism of the previous century as there is no longer any trace of this mysticism in Copernicus' book, *The Revolution of the Celestial Orbits*. In the work of both, the earth is no longer the cosmic center and man is no longer the crown of creation and the only hero of the cosmic drama; both are parts of a larger universe and their existence does not any more appear as the mystical and dematerialized phenomenon of the mediaeval age. At that time one and the same spirit governed the artistic studios of Florence and held sway under the arches of the Neapolitan Academy for the Empirical Study of Nature led by Telesio. This tie between Science and Art has never ceased to exist throughout the history of human culture, and we can discern it in whatever section of history we look. This fact explains many phenomena in the spiritual processes of our own century which brought our own generation to the Constructive idea in Art.

The immediate source from which the Constructive idea derives is Cubism, although it had almost the character of a repulsion rather than an attraction. The Cubistic school was the summit of a revolutionary process in Art which was already started by the Impressionists at the end of the last century. One may estimate the value of particular Cubistic works as one likes, but it is incontestable that the influence of the Cubistic ideology on the spirits of the artists at the beginning of this century has no parallel in the history of Art for violence and intrepidity. The revolution which this school produced in the minds of artists is only comparable to that which happened at approximately the same time in the world of physics. Many falsely assume that the birth of Cubistic ideology was caused by the fashion for Negro art which was prevalent at that time; but in reality Cubism was a purely European phenomenon and its substance has nothing in common with the demonism of primitive tribes. The Cubistic ideology has a highly differentiated character and its manifestation could only be possible in the atmosphere of a refined culture. In fact it wants an especially sharpened and cultivated capacity for analytic thought to undertake the task of revaluation of old values in Art and to perform it with violence as the Cubistic school did. All previous schools in Art have

been in comparison merely reformers; Cubism was a revolution. It was directed against the fundamental basis of Art. All that was before holy and intangible for an artistic mind, namely, the formal unity of the external world, was suddenly laid down on their canvases, torn in pieces and dissected as if it were a mere anatomical specimen. The borderline which separated the external world from the artist and distinguished it in forms of objects disappeared; the objects themselves disintegrated into their component parts and a picture ceased to be an image of the visible forms of an object as a unit, a world in itself, but appeared as a mere picture analysis of the inner mechanism of its cells. The medium between the inner world of the artist and the external world had lost its extension, and between the inner world of the perceptions of the artist and the outer world of existing things there was no longer any substantial medium left which could be measured either by distance or by mind. The contours of the external world which served before as the only guides to an orientation in it were erased; even the necessity for orientation lost its importance and was replaced by other problems, those of exploration and analysis. The creative act of the Cubists was entirely at variance with any which we have observed before. Instead of taking the object as a separate world and passing it through his perceptions producing a third object, namely, the picture, which is the product of the first two, the Cubist transfers the entire inner world of his perceptions with all its component parts (logic, emotion, and will) into the interior of the object penetrating through its whole structure, stretching its substance to such an extent that the outside integument explodes and the object itself appears destroyed and unrecognizable. That is why a Cubist painting seems like a heap of shards from a vessel exploded from within. The Cubist has no special interest in those forms which differentiate one object from another.

Although the Cubists still regarded the external world as the point of departure for their Art, they did not see and did not want to see any difference between, say, a violin, a tree, a human body, etc. All those objects were for them only one extended matter with a unique structure and only this structure was of importance for their analytic task. It is understandable that in such an artistic concept of the world the details must possess unexpected dimensions and the parts acquire the value of entities, and in the inner relations between them the disproportion grows to such an extent that all inherited ideas about harmony are destroyed. When we look through a Cubistic painting to its concept of the world the

same thing happens to us as when we enter the interior of a building which we know only from a distance—it is surprising, unrecognizable, and strange. The same thing happens which occurred in the world of physics when the new Relativity Theory destroyed the borderlines between Matter and Energy, between Space and Time, between the mystery of the world in the atom and the consistent miracle of our galaxy.

I do not mean to say by this that these scientific theories have affected the ideology of the Cubists, one must rather presume that none of those artists had so much as heard of or studied those theories. It is much more probable that they would not have apprehended them even if they had heard about them, and in the end it is entirely superfluous. The state of ideas in this time has brought both creative disciplines to adequate results, each in its own field, so that the edifice of Art as well as the edifice of Science was undermined and corroded by a spirit of fearless analysis which ended in a revolutionary explosion. Yet the destruction produced in the world of Art was more violent and more thorough.

Our own generation found in the world of Art after the work of the Cubists only a conglomeration of ruins. The Cubistic analysis had left for us nothing of the old traditions on which we could base even the flimsiest foundation. We have been compelled to start from the beginning. We had a dilemma to resolve, whether to go further on the way of destruction or to search for new bases for the foundation of a new Art. Our choice was not so difficult to make. The logic of life and the natural artistic instinct prompted us with its solution.

The logic of life does not tolerate permanent revolutions. They are possible on paper but in real life a revolution is only a means, a tool but never an aim. It allows the destruction of obstacles which hinder a new construction, but destruction for destruction's sake is contrary to life. Every analysis is useful and even necessary, but when this analysis does not care about the results, when it excludes the task of finding a synthesis, it turns to its opposite, and instead of clarifying a problem it only renders it more obscure. Life permits to our desire for knowledge and exploration the most daring and courageous excursions, but only to the explorers who, enticed far away into unknown territories, have not forgotten to notice the way by which they came and the aim for which they started. In Art more than anywhere else in the creative discipline, daring expeditions are allowed. The most dizzying experiments are per-

missible, but even in Art the logic of life arrests the experiments as soon as they have reached the point when the death of the experimental objects becomes imminent. There were moments in the history of Cubism when the artists were pushed to these bursting points; sufficient to recall the sermons of Picabia, 1914-16, predicting the wreck of Art, and the manifestos of the Dadaists who already celebrated the funeral of Art with chorus and demonstrations. Realizing how near to complete annihilation the Cubist experiments had brought Art, many Cubists themselves have tried to find a way out, but the lack of consequence has merely made them afraid and has driven them back to Ingres (Picasso, 1919-23) and to the Gobelins of the sixteenth century (Braque, etc.). This was not an outlet but a retreat. Our generation did not need to follow them since it has found a new concept of the world represented by the Constructive idea.

The Constructive idea is not a programmatic one. It is not a technical scheme for an artistic manner, nor a rebellious demonstration of an artistic sect; it is a general concept of the world, or better, a spiritual state of a generation, an ideology caused by life, bound up with it and directed to influence its course. It is not concerned with only one discipline in Art (painting, sculpture, or architecture) it does not even remain solely in the sphere of Art. This idea can be discerned in all domains of the new culture now in construction. This idea has not come with finished and dry formulas, it does not establish immutable laws or schemes, it grows organically along with the growth of our century. It is as young as our century and as old as the human desire to create.

The basis of the Constructive idea in Art lies in an entirely new approach to the nature of Art and its functions in life. In it lies a complete reconstruction of the means in the different domains of Art, in the relations between them, in their methods, and in their aims. It embraces those two fundamental elements on which Art is built up, namely, the Content and the Form. These two elements are, from the Constructive point of view, one and the same thing. It does not separate Content from Form—on the contrary, it does not see as possible their separated and independent existence. The thought that Form could have one designation and Content another cannot be incorporated in the concept of the Constructive idea. In a work of art they have to live and act as a unit, proceed in the same direction and produce the same effect. I say "have to" because never before in Art have they acted in such a way in spite of the obvious

necessity of this condition. It has always been so in Art that either one or the other predominated, conditioning and predetermining the other.

This was because in all our previous Art concepts of the world a work of art could not have been conceived without the representation of the external aspect of the world. Whichever way the artist presented the outside world, either as it is or as seen through his personal perceptions, the external aspect remained as the point of departure and the kernel of its content. Even in those cases where the artist tried to concentrate his attention only on the inner world of his perceptions and emotions, he could not imagine the picture of this inner world without the images of the outer one. The most that he could dare in such cases was the more or less individual distortions of the external images of Nature; that is, he altered only the scale of the relations between the two worlds, always keeping to the main system of its content, but did not attack the fact of their independence; and this indestructible content in a work of art always predicted the forms which Art has followed down to our own time.

The apparently ideal companionship between Form and Content in the old Art was indeed an unequal division of rights and was based on the obedience of the Form to the Content. This obedience is explained by the fact that all formalistic movements in the history of Art, whenever they appeared, never went so far as to presume the possibility of an independent existence of a work apart from the naturalistic content, nor to suspect that there might be a concept of the world which could reveal a Content in a Form.

This was the main obstacle to the rejuvenation of Art, and it was at this point that the Constructive idea laid the cornerstone of its foundation. It has revealed a universal law that the elements of a visual art, such as lines, colors, shapes, possess their own forces of expression independent of any association with the external aspects of the world; that their life and their action are self-conditioned psychological phenomena rooted in human nature; that those elements are not chosen by convention for any utilitarian or other reason as words and figures are, they are not merely abstract signs, but they are immediately and organically bound up with human emotions. The revelation of this fundamental law has opened up a vast new field in art giving the possibility of expression to those human impulses and emotions which have been neglected. Heretofore these elements have been abused by being used to express all sorts of associative images which might have

been expressed otherwise, for instance, in literature and poetry.

But this point was only one link in the ideological chain of the constructive concept, being bound up with the new conception of Art as a whole and of its functions in life. The Constructive idea sees and values Art only as a creative act. By a creative act it means every material or spiritual work which is destined to stimulate or perfect the substance of material or spiritual life. Thus the creative genius of Mankind obtains the most important and singular place. In the light of the Constructive idea the creative mind of Man has the last and decisive word in the definite construction of the whole of our culture. To be sure, the creative genius of Man is only a part of Nature, but from this part alone derives all the energy necessary to construct his spiritual and material edifice. Being a result of Nature it has every right to be considered as a further cause of its growth. Obedient to Nature, it intends to become its master; attentive to the laws of Nature it intends to make its own laws, following the forms of Nature it re-forms them. We do not need to look for the origin of this activity, it is enough for us to state it and to feel its reality continually acting on us. Life without creative effort is unthinkable, and the whole course of human culture is one continuous effort of the creative will of Man. Without the presence and the control of the creative genius, Science by itself would never emerge from the state of wonder and contemplation from which it is derived and would never have achieved substantial results. Without the creative desire Science would go astray in its own schemes, losing its aim in its reasoning. No criterion could be established in any spiritual discipline without this creative will. No way could be chosen, no direction indicated without its decision. There are no truths beyond its truths. How many of them life hides in itself, how different they are and how inimical. Science is not able to resolve them. One scientist says, "The truth is here"; another says, "It is there"; while a third says, "It is neither here nor there, but somewhere else." Every one of them has his own proof and his own reason for saying so, but the creative genius does not wait for the end of their discussion. Knowing what it wants, it makes a choice and decides for them.

The creative genius knows that truths are possible everywhere, but only those truths matter to it which correspond to its aims and which lie in the direction of its course. The way of a creative mind is always positive, it always asserts; it does not know the doubts which are so characteristic of the scientific mind. In this case it acts as Art.

The Constructive idea does not see that the function of Art is to represent the world. It does not impose on Art the function of Science. Art and Science are two different streams which rise from the same creative source and flow into the same ocean of the common culture, but the currents of these two streams flow in different beds. Science teaches, Art asserts; Science persuades, Art acts; Science explores and apprehends, informs and proves. It does not undertake anything without first being in accord with the laws of Nature. Science cannot deal otherwise because its task is knowledge. Knowledge is bound up with things which are; and things which are, are heterogeneous, changeable, and contradictory. Therefore the way to the ultimate truth is so long and difficult for Science.

The force of Science lies in its authoritative reason. The force of Art lies in its immediate influence on human psychology and in its active contagiousness. Being a creation of Man it re-creates Man. Art has no need of philosophical arguments, it does not follow the signposts of philosophical systems; Art, like life, dictates systems to philosophy. It is not concerned with the meditation about what is and how it came to be. That is a task for Knowledge. Knowledge is born of the desire to know, Art derives from the necessity to communicate and to announce. The stimulus of Science is the deficiency of our knowledge. The stimulus of Art is the abundance of our emotions and our latent desires. Science is the vehicle of facts—it is indifferent, or at best tolerant, to the ideas which lie behind facts. Art is the vehicle of ideas and its attitude to facts is strictly partial. Science looks and observes, Art sees and foresees. Every great scientist has experienced a moment when the artist in him saved the scientist. "We are poets," said Pythagoras, and in the sense that a mathematician is a creator he was right.

In the light of the Constructive idea the purely philosophical wondering about real and unreal is idle. Even more idle is the intention to divide the real into super-real and sub-real, into conscious reality and subconscious reality. The Constructive idea knows only one reality. Nothing is unreal in Art. Whatever is touched by Art becomes reality, and we do not need to undertake remote and distant navigations in the subconscious in order to reveal a world which lies in our immediate vicinity. We feel its pulse continually beating in our wrists. In the same way we shall probably never have to undertake a voyage in interstellar space in order to feel the breath of the galactic orbits. This breath is fanning our heads within the four walls of our own rooms.

There is and there can be only one reality—existence. For the

Constructive idea it is more important to know and to use the main fact that Art possesses in its own domain the means to influence the course of this existence enriching its content and stimulating its energy.

This does not mean that this idea constantly compels Art to an immediate construction of material values in life; it is sufficient when Art prepares a state of mind which will be able only to construct, coordinate and perfect instead of to destroy, disintegrate and deteriorate. Material values will be the inevitable result of such a state. For the same reason the Constructive idea does not expect from Art the performance of critical functions even when they are directed against the negative sides of life. What is the use of showing us what is bad without revealing what is good? The Constructive idea prefers that Art perform positive works which lead us toward the best. The measure of this perfection will not be so difficult to define when we realize that it does not lie outside us but is bound up in our desire and in our will to it. The creative human genius, which never errs and never mistakes, defines this measure. Since the beginning of Time man has been occupied with nothing else but the perfecting of his world.

To find the means for the accomplishment of this task the artist need not search in the external world of Nature; he is able to express his impulses in the language of those absolute forms which are in the substantial possession of his Art. This is the task which we constructive artists have set ourselves, which we are doing, and which we hope will be continued by the future generation.

Mondrian
Plastic Art &
Pure Plastic Art

Plastic Art and Pure Plastic Art is the most influential of several essays by Mondrian, and one of the few by any artist which constructs a complete, integral aesthetic system.

In 1917 Piet Mondrian (1872-1944) had been one of the principal founders of the Dutch movement *de Stijl*, but he left to Van Doesburg the role of principal propagandist. He returned to Paris after the war (he had earlier lived there, from 1911 to 1914), and in 1920 published his first major essay, *Le Néo-Plasticisme*. Here and in subsequent writings he worked out many of the elements of the 1937 essay. In Paris until 1938, then in London for two years, Mondrian moved to New York City when the war broke out, and died there in 1944. The war years in New York were among his most productive as an artist-essayist, three essays being published in 1942 alone.

Plastic Art and Pure Plastic Art is a brilliant essay because, like Mondrian's paintings, it makes no compromises. Since it is an extreme, it will at first prove difficult, especially because Mondrian redefines such words as "subjectivity" and "objectivity," but the alert reader will soon be caught up in a remarkable challenge to his concepts of what is "real" and what is art.

The essay originally appeared in *Circle,* edited by Naum Gabo, J. L. Martin, and Ben Nicholson (London, 1937). The text here, with only a few words changed later by Mondrian, comes from *Plastic Art and Pure Plastic Art and*

Other Essays, one of the series "Documents of Modern
Art," edited by Robert Motherwell for Wittenborn, Schultz
(New York, 1945). Harry Holtzman, who wrote the intro-
duction to that volume, has permitted me to republish the
essay, for which he has my warmest gratitude. He is editing
the collected writings of Mondrian for publication.

Plastic Art & Pure Plastic Art

Part I

Although Art is fundamentally everywhere and always the same,
nevertheless two main human inclinations, diametrically opposed
to each other, appear in its many and varied expressions. One aims
at the *direct creation of universal beauty,* the other at the *esthetic
expression of oneself,* in other words, of that which one thinks and
experiences. The first aims at representing reality objectively, the
second subjectively. Thus we see in every work of figurative art the
desire, objectively to represent beauty, solely through form and
color, in mutually balanced relations, and, at the same time, an
attempt to express that which these forms, colors, and relations
arouse in us. This latter attempt must of necessity result in an
individual expression which veils the pure representation of beauty.
Nevertheless, both the two opposing elements (universal-individual)
are indispensable if the work is to arouse emotion. Art had to find
the right solution. In spite of the dual nature of the creative
inclinations, figurative art has produced a harmony through a
certain coordination between objective and subjective expression.
For the spectator, however, who demands a pure representation of
beauty, the individual expression is too predominant. For the artist
the search for a unified expression through the balance of two
opposites has been, and always will be, a continual struggle.

Throughout the history of culture, art has demonstrated that
universal beauty does not arise from the particular character of the
form, but from the dynamic rhythm of its inherent relationships,
or—in a composition—from the mutual relations of forms. Art has
shown that it is a question of determining the relations. It has
revealed that the forms exist only for the creation of relationships;
that forms create relations and that relations create forms. In this
duality of forms and their relations neither takes precedence.

The only problem in art is to achieve a balance between the

subjective and the objective. But it is of the utmost importance that this problem should be solved, in the realm of plastic art—technically, as it were—and not in the realm of thought. The work of art must be "produced," "constructed." One must create as objective as possible a representation of forms and relations. Such work can never be empty because the opposition of its constructive elements and its execution arouse emotion.

If some have failed to take into account the inherent character of the form and have forgotten that this—untransformed—predominates, others have overlooked the fact that an individual expression does not become a universal expression through figurative representation, which is based on our conception of feeling, be it classical, romantic, religious, surrealist. Art has shown that universal expression can only be created by *a real equation of the universal and the individual.*

Gradually art is purifying its plastic means and thus bringing out the relationships between them. Thus, in our day two main tendencies appear: the one maintains the figuration, the other eliminates it. While the former employs more or less complicated and particular forms, the latter uses simple and neutral forms, or, ultimately, the free line and the pure color. It is evident that the latter (non-figurative art) can more easily and thoroughly free itself from the domination of the subjective than can the figurative tendency; particular forms and colors (figurative art) are more easily exploited than neutral forms. It is, however, necessary to point out, that the definitions "figurative" and "non-figurative" are only approximate and relative. For every form, even every line, represents a figure; no form is absolutely neutral. Clearly, everything must be relative, but, since we need words to make our concepts understandable, we must keep to these terms.

Among the different forms we may consider those as being neutral which have neither the complexity nor the particularities possessed by the natural forms or abstract forms in general. We may call those neutral which do not evoke individual feelings or ideas. Geometrical forms being so profound an abstraction of form may be regarded as neutral; and on account of their tension and the purity of their outlines they may even be preferred to other neutral forms.

If, as a conception, non-figurative art has been created by the mutual interaction of the human duality, this art has been *realized* by the mutual interaction of *constructive elements and their inherent relations.* This process consists in mutual purification; puri-

fied constructive elements set up pure relationships, and these in their turn demand pure constructive elements. Figurative art of today is the outcome of figurative art of the past, and non-figurative art is the outcome of the figurative art of today. Thus the unity of art is maintained.

If non-figurative art is born of figurative art, it is obvious that the two factors of human duality have not only changed, but have also approached one another toward a mutual balance, toward unity. One can rightly speak of an *evolution in plastic art*. It is of the greatest importance to note this fact, for it reveals the true way of art; the only path along which we can advance. Moreover, the evolution of the plastic arts shows that the dualism which has manifested itself in art is only relative and temporal. Both science and art are discovering and making us aware of the fact that *time is a process of intensification*, an evolution from the individual toward the universal, of the subjective toward the objective; toward the essence of things and of ourselves.

A careful observation of art since its origin shows that artistic expression seen from the outside is *not a process of prolongment but of intensifying one and the same thing*, universal beauty; and that seen from the inside *it is a growth*. Extension results in a continual repetition of nature; it is not human and art cannot follow it. So many of these repetitions which parade as "art" clearly cannot arouse emotions.

Through intensification one creates successively on more profound planes; extension remains always on the same plane. Intensification, be it noted, is diametrically opposed to extension; they are at right angles to each other as are length and depth. This fact shows clearly the temporal opposition of non-figurative and figurative art.

But if throughout its history art has meant a *continuous and gradual change in the expression of one and the same thing*, the opposition of the two trends—in our time so clear-cut—is actually an unreal one. It is illogical that the two principal tendencies in art, figurative and non-figurative (objective and subjective) should be so hostile. Since art is in essence universal, its expression cannot rest on a subjective view. Our human capacities do not allow of a perfectly objective view, but that does not imply that the plastic expression of art is based on subjective conception. Our subjectivity realizes but does not create the work.

If the two human inclinations already mentioned are apparent in a work of art, they have both collaborated in its realization, but

it is evident that the work will clearly show which of the two has predominated. In general, owing to the complexity of forms and the vague expression of relations, the two creative inclinations will appear in the work in a confused manner. Although in general there remains much confusion, today the two inclinations appear more clearly defined as two tendencies: *figurative and non-figurative art.* So-called non-figurative art often also creates a particular representation; figurative art, on the other hand, often neutralizes its forms to a considerable extent. The fact that art which is really non-figurative is rare does not detract from its value; evolution is always the work of pioneers, and their followers are always small in number. This following is not a clique; it is the result of all the existing social forces; it is composed of all those who through innate or acquired capacity are ready to represent the existing degree of human evolution. At a time when so much attention is paid to the collective, to the "mass," it is necessary to note that evolution, ultimately, is never the expression of the mass. The mass remains behind yet urges the pioneers to creation. For the pioneers, the social contact is indispensable, but not in order that they may know that what they are doing is necessary and useful, nor in order that "collective approval may help them to persevere and nourish them with living ideas." This contact is necessary only in an indirect way; it acts especially as an obstacle which increases their determination. The pioneers create through their reaction to external stimuli. They are guided not by the mass but by that which they see and feel. They discover consciously or unconsciously the fundamental laws hidden in reality, and aim at realizing them. In this way they further human development. They know that humanity is not served by making art comprehensible to everybody; to try this is to attempt the impossible. One serves mankind by enlightening it. Those who do not see will rebel, they will try to understand and will end up by "seeing." In art the search for a content which is collectively understandable is false; the content will always be individual. Religion, too, has been debased by that search.

Art is not made for anybody and is, at the same time, for everybody. It is a mistake to try to go too fast. The complexity of art is due to the fact that different degrees of its evolution are present at one and the same time. The present carries with it the past and the future. But we need not try to foresee the future; we need only take our place in the development of human culture, a development which has made non-figurative art supreme. It has always been only one struggle, of only one real art: to create universal

beauty. This points the way for both present and future. We need only continue and develop what already exists. The essential thing is that the *fixed laws of the plastic arts must be realized.* These have shown themselves clearly in non-figurative art.

Today one is tired of the dogmas of the past, and of truths once accepted but successively jettisoned. One realizes more and more the relativity of everything, and therefore one tends to reject the idea of fixed laws, of a single truth. This is very understandable but does not lead to profound vision. For there are "made" laws, "discovered" laws, but also laws—a truth for all time. These are more or less hidden in the reality which surrounds us and do not change. Not only science, but art also, shows us that reality, at first incomprehensible, gradually reveals itself, by the mutual relations that are inherent in things. Pure science and pure art, disinterested and free, can lead the advance in the recognition of the laws which are based on these relationships. A great scholar has recently said that pure science achieves practical results for humanity. Similarly, one can say that pure art, even though it appear abstract, can be of direct utility for life.

Art shows us that there are also constant truths concerning forms. Every form, every line has its own expression. This objective expression can be modified by our subjective view but it is no less true for that. Round is always round and square is always square. Simple though these facts are, they often appear to be forgotten in art. Many try to achieve one and the same end by different means. In plastic art this is an impossibility. In plastic art it is necessary to choose constructive means which are of one piece with that which one wants to express.

Art makes us realize that there are *fixed laws which govern and point to the use of the constructive elements, of the composition and of the inherent interrelationships between them.* These laws may be regarded as subsidiary laws to the *fundamental* law of equivalence which creates *dynamic equilibrium and reveals the true content of reality.*

Part II

We live in a difficult but interesting epoch. After a secular culture, a turning point has arrived; this shows itself in all the branches of human activity. Limiting ourselves here to science and art, we notice that, just as in medicine some have discovered the natural laws relating to physical life, in art some have discovered

the artistic laws relating to plastics. In spite of all opposition, these facts have become movements. But confusion still reigns in them. Through science we are becoming more and more conscious of the fact that our physical state depends in great measure on what we eat, on the manner in which our food is arranged and on the physical exercise which we take. Through art we are becoming more and more conscious of the fact that the work depends in large measure on the constructive elements which we use and on the construction which we create. We will gradually realize that we have not hitherto paid sufficient attention to constructive physical elements in their relation to the human body, nor to the constructive plastic elements in their relation to art. That which we eat has deteriorated through a refinement of natural produce. To say this, appears to invoke a return to a primitive natural state and to be in opposition to the exigencies of pure plastic art, which degenerates precisely through figurative trappings. But a return to pure natural nourishment does not mean a return to the state of primitive man; it means on the contrary that cultured man obeys the laws of nature discovered and applied by science.

Similarly in non-figurative art, to recognize and apply natural laws is not evidence of a retrograde step; the pure abstract expression of these laws proves that the exponent of non-figurative art associates himself with the most advanced progress and the most cultured minds, that he is an exponent of denaturalized nature, of civilization.

In life, sometimes the spirit has been overemphasized at the expense of the body, sometimes one has been preoccupied with the body and neglected the spirit; similarly in art, content and form have alternately been overemphasized or neglected because *their inseparable unity* has not been clearly realized.

To create this unity in art *balance of the one and the other must be created.*

It is an achievement of our time to have approached such balance in a field in which disequilibrium still reigns.

Disequilibrium means conflict, disorder. Conflict is also a part of life and of art, but it is not the whole of life or universal beauty. Real life is the *mutual interaction of two oppositions of the same value but of a different aspect and nature.* Its plastic expression is universal beauty.

In spite of world disorder, instinct and intuition are carrying humanity to a real equilibrium, but how much misery has been and is still being caused by primitive animal instinct. How many

errors have been and are being committed through vague and confused intuition? Art certainly shows this clearly. But art shows also that in the course of progress, intuition becomes more and more conscious and instinct more and more purified. Art and life illuminate each other more and more; they reveal more and more their laws according to which a real and living balance is created.

Intuition enlightens and so links up with pure thought. They together become an intelligence which is not simply of the brain, which does not calculate, but which feels and thinks. Which is creative both in art and in life. From this intelligence there must arise non-figurative art in which instinct no longer plays a dominating part. Those who do not understand this intelligence regard non-figurative art as a purely intellectual product.

Although all dogma, all preconceived ideas, must be harmful to art, the artist can nevertheless be guided and helped in his intuitive researches by reasoning apart from his work. If such reasoning can be useful to the artist and can accelerate his progress, it is indispensable that such reasoning should accompany the observations of the critics who talk about art and who wish to guide mankind. Such reasoning, however, cannot be individual, which it usually is; it cannot arise out of a body of knowledge outside plastic art. If one is not an artist oneself one must at least know the *laws and culture of plastic art*. If the public is to be well informed and if mankind is to progress it is essential that the confusion which is everywhere present should be removed. For enlightenment, a clear demonstration of the *succession of artistic tendencies is necessary*. Hitherto, a study of the different styles of plastic art in their progressive succession has been difficult since the expression of the essence of art has been veiled. In our time, which is reproached for not having a style of its own, the content of art has become clear and the different tendencies reveal more clearly the progressive succession of artistic expression. Non-figurative art brings to an end the ancient culture of art; at present, therefore, one can review and judge more surely *the whole culture of art*. We are now at the turning-point of this culture; *the culture of particular form is approaching its end. The culture of determined relations has begun.*

It is not enough to explain the value of a work of art in itself; it is above all necessary to show *the place which a work occupies on the scale of the evolution of plastic art*. Thus in speaking of art, it is not permissible to say "this is how I see it" or "this is my idea." True art like true life takes a *single road*.

The laws which in the culture of art have become more and more

determinate are the *great hidden laws of nature which art estab-lishes in its own fashion*. It is necessary to stress the fact that these laws are more or less hidden behind the superficial aspect of nature. Abstract art is therefore opposed to a natural representation of things. But it *is not opposed to nature* as is generally thought. It is opposed to the raw primitive animal nature of man, but it is one with true human nature. It is opposed to the conventional laws created during the culture of the particular form but it is one with the laws of the culture of pure relationships.

First and foremost there is the fundamental law of *dynamic equilibrium* which is opposed to the static equilibrium necessitated by the particular form.

The important task then of all art is to destroy the static equilibrium by establishing a dynamic one. Non-figurative art demands an attempt of what is a consequence of this task, the *destruction* of particular form and the *construction* of a rhythm of mutual relations, of mutual forms or free lines. We must bear in mind, however, a distinction between these two forms of equilibrium in order to avoid confusion; for when we speak of equilibrium pure and simple we may be for, and at the same time against, a balance in the work of art. It is of the greatest importance to note the destructive-constructive quality of dynamic equilibrium. Then we shall understand that the equilibrium of which we speak in non-figurative art is not without movement of action but is on the contrary a continual movement. We then understand also the significance of the name "constructive art."

The fundamental law of dynamic equilibrium gives rise to a number of other laws which relate to the constructive elements and their relations. These laws determine the manner in which dynamic equilibrium is achieved. The relations of *position* and those of *dimension* both have their own laws. Since the relation of the rectangular position is constant, it will be applied whenever the work demands the expression of stability; to destroy this stability there is a law that relations of a changeable dimension-expression must be substituted. The fact that all the relations of position except the rectangular one lack that stability, also creates a law which we must take into account if something is to be established in a determinate manner. Too often right and oblique angles are arbitrarily employed. All art expresses the rectangular relationship even though this may not be in a determinate manner; first by the height and width of the work and its constructive forms, then by the mutual relations of these forms. Through the clarity and simplicity of

neutral forms, non-figurative art has made the rectangular relation more and more determinate until, finally, it has established it through free lines which intersect and appear to form rectangles.

As regards the relations of dimension, they must be varied in order to avoid repetition. Although, as compared with the stable expression of the rectangular relationship, they belong to individual expression, it is precisely they that are most appropriate for the destruction of the static equilibrium of all form. By offering him a freedom of choice the relations of dimension *present the artist with one of the most difficult problems*. And the closer he approaches the ultimate consequence of his art the more difficult is his task.

Since the constructive elements and their mutual relations form an inseparable unity, the laws of the relations govern equally the constructive elements. These, however, have also their own laws. It is obvious that one cannot achieve the same expression through different forms. But it is often forgotten that varied forms or lines *achieve—in form—altogether different degrees in the evolution of plastic art*. Beginning with natural forms and ending with the most abstract forms, *their expression becomes more profound*. Gradually form and line gain in tension. For this reason the straight line *is* a stronger and more profound expression than the curve.

In pure plastic art the significance of different forms and lines is very important; it is precisely this fact which makes it pure.

In order that art may be really abstract, in other words, that it should not represent relations with the natural aspect of things, the law of the *denaturalization of matter* is of fundamental importance. In painting, the primary color that is as pure as possible realizes this abstraction of natural color. But color is, in the present state of technique, also the best means for denaturalizing matter in the realm of abstract constructions in three dimensions; technical means are as a rule insufficient.

All art has achieved a certain measure of abstraction. This abstraction has become more and more accentuated until in pure plastic art not only a transformation of form but also of matter—be it through technical means or through color—a more or less neutral expression is attained.

According to our laws, it is a great mistake to believe that one is practicing non-figurative art by merely achieving neutral forms or free lines and determinate relations. For in composing these forms one runs the risk of a figurative creation, that is to say one or more particular forms.

Non-figurative art is created by establishing *a dynamic rhythm*

of determinate mutual relations which *excludes the formation of any particular form.* We note thus, that to destroy particular form is only to do more consistently what all art has done.

The dynamic rhythm which is essential in all art is also the essential element of a non-figurative work. In figurative art this rhythm is veiled.

Yet we all pay homage to clarity.

The fact that people generally prefer figurative art (which creates and finds its continuation in abstract art) can be explained by the dominating force of the individual inclination in human nature. *From this inclination arises all the opposition to art which is purely abstract.*

In this connection we note first the *naturalistic conception* and the *descriptive or literary orientation:* both a real danger to purely abstract art. From a purely plastic point of view, until non-figurative art, artistic expression has been naturalistic or descriptive. To have emotion aroused by pure plastic expression one must abstract from figuration and so become "neutral." But with the exception of some artistic expressions (such as Byzantine art)[1] there has not been the desire to employ neutral plastic means, which would have been much more logical than to become neutral oneself in contemplating a work of art. Let us note, however, that the spirit of the past was different from the spirit of our own day, and that it is only tradition which has carried the past into our own time. In past times when one lived in contact with nature and when man himself was more natural than he is today, abstraction from figuration in thought was easy; it was done unconsciously. But in our more or less denaturalized period, such abstraction becomes an effort.

However that may be, the fact that figuration is a factor which is unduly taken into account, and whose abstraction in the mind is only relative, proves that today even great artists regard figuration as indispensable. At the same time these artists are already abstracting from figuration to a much greater extent than has been done before. More and more, not only the uselessness of figuration, but also obstacles which it creates, will become obvious. In this search for clarity, non-figurative art develops.

There is, however, one tendency which cannot forgo figuration without losing its descriptive character. That is surrealism. Since the predominance of individual thought is opposed to pure plastics

[1] As regards these works we must note that, lacking a dynamic rhythm, they remain, in spite of the profound expression of forms, more or less ornamental.

it is also opposed to non-figurative art. Born of a literary movement,
its descriptive character demands figuration. However purified or
deformed it may be, figuration veils pure plastics. There are, it is
true, surrealist works whose plastic expression is very strong and of
a kind that if the work is observed at a distance, i.e., if the figura-
tive representation is abstracted from, they arouse emotion by form,
color, and their relations alone. But if the purpose was nothing but
plastic expression, why then use figurative representation? Clearly,
there must have been the intention to express something outside the
realm of pure plastics. This of course is often the case even in
abstract art. There, too, there is sometimes added to the abstract
forms something particular, even without the use of figuration;
through the color or through the execution, a particular idea or
sentiment is expressed. There it is generally not the literary inclina-
tion but the naturalistic inclination which has been at work. It
must be obvious that if one evokes in the spectator the sensation of,
say, the sunlight or moonlight, of joy or sadness, or any other
determinate sensation, one has not succeeded in establishing univer-
sal beauty, one is not purely abstract.

As for surrealism, we must recognize that it deepens feeling and
thought, but since this deepening is limited by individualism it can-
not reach the foundation, the universal. So long as it remains in the
realm of dreams, which are only a rearrangement of the events of
life, it cannot touch true reality. Through a different composition
of the events of life, it may remove their ordinary course but it
cannot purify them. Even the intention of freeing life from its
conventions and from everything which is harmful to the true life
can be found in surrealist literature. Non-figurative art is fully in
agreement with this intention but it achieves its purpose; it frees
its plastic means and its art from all particularity. The names,
however, of these tendencies, are only indications of their concep-
tions; it is the realization which matters. With the exception of
non-figurative art, there seems to have been a lack of realization of
the fact that it is possible to express oneself profoundly and hu-
manely by plastics alone, that is, by employing a neutral plastic
means without the risk of falling into decoration or ornament. Yet
all the world knows that even a single line can arouse emotion. But
although one sees—and this is the artist's fault—few non-figurative
works which live by virtue of their dynamic rhythm and their
execution, figurative art is no better in this respect. In general,
people have not realized that one can express our very essence
through neutral constructive elements; that is to say, we can express

the essence of art. The essence of art of course is not often sought. As a rule, individualist human nature is so predominant, that the expression of the essence of art through a rhythm of lines, colors, and relationships appears insufficient. Recently, even a great artist has declared that "complete indifference to the subject leads to an incomplete form of art."

But everybody agrees that art is only a problem of plastics. What good then is a subject? It is to be understood that one would need a subject to expound something named "Spiritual riches, human sentiments and thoughts." Obviously, all this is individual and needs particular forms. But at the root of these sentiments and thoughts there is one thought and one sentiment: these do not easily define themselves and have no need of analogous forms in which to express themselves. It is here that neutral plastic means are demanded.

For pure art then, the subject can never be an additional value, it is the line, the color, and their relations which must "bring into play the whole sensual and intellectual register of the inner life . . . ," not the subject. Both in abstract art and in naturalistic art color expresses itself "in accordance with the form by which it is determined," and in all art it is the artist's task to make forms and colors living and capable of arousing emotion. If he makes art into an "algebraic equation" that is no argument against the art, it only proves that he is not an artist.

If all art has demonstrated that to establish the force, tension and movement of the forms, and the intensity of the colors of reality, it is necessary that these should be purified and transformed; if all art has purified and transformed and is still purifying and transforming these forms of reality and their mutual relations, if all art is thus a continually deepening process: why then stop halfway? If all art aims at expressing universal beauty, why establish an individualist expression? Why then not continue the sublime work of the cubists? That would not be a continuation of the same tendency, but on the contrary, *a complete break-away from it and all that has existed before it*. That would only be going along the same road that we have already travelled.

Since cubist art is still fundamentally naturalistic, the break which pure plastic art has caused consists in becoming abstract instead of naturalistic in essence. While in cubism, from a naturalistic foundation, there sprang forcibly the use of plastic means, still half object, half abstract, the abstract basis of pure plastic art must result in the use of purely abstract plastic means.

In removing completely from the work all objects, "the world is not separated from the spirit," but is on the contrary *put into a balanced opposition* with the spirit, since the one and the other are purified. This creates a perfect unity between the two opposites. There are, however, many who imagine that they are too fond of life, particular reality, to be able to suppress figuration, and for that reason they still use in their work the object or figurative fragments which indicate its character. Nevertheless, one is well aware of the fact that in art one cannot hope to represent in the image things as they are, nor even as they manifest themselves in all their living brilliance. The impressionists, divisionists, and pointillists have already recognized that. There are some today who, recognizing the weakness and limitation of the image, attempt to create a work of art through the objects themselves, often by composing them in a more or less transformed manner. This clearly cannot lead to an expression of their content nor of their true character. One can more or less remove the conventional appearance of things (surrealism), but they continue nevertheless to show their particular character and to arouse in us individual emotions. To love things in reality is to love them profoundly; it is to see them as a microcosmos in the macrocosmos. *Only in this way can one achieve a universal expression of reality.* Precisely on account of its profound love for things, non-figurative art does not aim at rendering them in their particular appearance.

Precisely by its existence non-figurative art shows that "art" *continues always on its true road.* It shows that "art" is *not the expression of the appearance of reality such as we see it, nor of the life which we live,* but that *it is the expression of true reality and true life . . . indefinable but realizable in plastics.*

Thus we must carefully distinguish between two kinds of reality; one which has an individual and one which has a universal appearance. In art the former is the expression of space determined by particular things or forms, the latter establishes expansion and limitation—the creative factors of space—through neutral forms, free lines, and pure colors. While universal reality arises from determinate relations, particular reality shows only veiled relations. The latter must obviously be confused in just that respect in which universal reality is bound to be clear. The one is free, the other is tied to individual life, be it personal or collective. Subjective reality and relatively objective reality: this is the contrast. Pure abstract art aims at creating the latter, figurative art the former.

It is astonishing, therefore, that one should reproach pure ab-

stract art with not being "real," and that one should envisage it as
"arising from particular ideas."

In spite of the existence of non-figurative art, one is talking about
art today as if nothing determinate in relation to the new art
existed. Many neglect the real non-figurative art, and looking only
at the fumbling attempts and at the empty non-figurative works
which today are appearing everywhere, ask themselves whether the
time has not arrived "to integrate form and content" or "to unify
thought and form." But one should not blame non-figurative art for
that which is only due to the ignorance of its very content. If the
form is without content, without universal thought, it is the fault
of the artist. Ignoring that fact, one imagines that figuration, sub-
ject, particular form, could add to the work that which the plastic
itself is lacking. As regards the "content" of the work, we must note
that our "attitude with regard to things, our organized individual-
ity with its impulses, its actions, its reactions when in contact with
reality, the lights and shades of our spirit," etc., certainly do modify
the non-figurative work, but they do not constitute its content. We
repeat that its content cannot be described, and that it is only
through pure plastics and through the execution of the work that
it can be made apparent. Through this indeterminable content,
the non-figurative work is "fully human." Execution and technique
play an important part in the aim of establishing a more or less
objective vision which the essence of the non-figurative work de-
mands. The less obvious the artist's hand the more objective will
the work be. This fact leads to a preference for a more or less me-
chanical execution or to the employment of materials produced by
industry. Hitherto, of course, these materials have been imperfect
from the point of view of art. If these materials and their colors
were more perfect and if a technique existed by which the artist
could easily cut them up in order to compose his work as he con-
ceives it, an art more real and more objective in relation to life
than painting would arise. All these reflections evoke questions
which have already been asked many years ago, mainly: is art still
necessary and useful for humanity? Is it not even harmful to its
progress? Certainly the art of the past is superfluous to the new
spirit and harmful to its progress: just because of its beauty it
holds many people back from the new conception. The new art
is, however, still very necessary to life. In a clear manner it estab-
lishes the laws according to which a real balance is reached. More-
over, it must create among us a profoundly human and rich beauty
realized not only by the best qualities of the new architecture, but

also by all that the constructive art in painting and sculpture makes possible.

But although the new art is necessary, the mass is conservative. Hence these cinemas, these radios, these bad pictures which overwhelm the few works which are really of our era.

It is a great pity that those who are concerned with the social life in general do not realize the utility of pure abstract art. Wrongly influenced by the art of the past, the true essence of which escapes them, and of which they only see that which is superfluous, they make no effort to know pure abstract art. Through another conception of the word "abstract," they have a certain horror of it. They are vehemently opposed to abstract art because they regard it as something ideal and unreal. In general they use art as propaganda for collective or personal ideas, thus as literature. They are both in favor of the progress of the mass and against the progress of the elite, thus against the logical march of human evolution. Is it really to be believed that the evolution of the mass and that of the elite are incompatible? The elite rises from the mass; is it not therefore its highest expression?

To return to the execution of the work of art, let us note that it must contribute to a revelation of the subjective and objective factors in mutual balance. Guided by intuition, it is possible to attain this end. The execution is of the greatest importance in the work of art; it is through this, in large part, that intuition manifests itself and creates the essence of the work.

It is therefore a mistake to suppose that a non-figurative work comes out of the unconscious, which is a collection of individual and pre-natal memories. We repeat that it comes from pure intuition, which is at the basis of the subjective-objective dualism.

It is, however, wrong to think that the non-figurative artist finds impressions and emotions received from the outside useless, and regards it even as necessary to fight against them. On the contrary, all that the non-figurative artist receives from the outside is not only useful but indispensable, because it arouses in him the desire to create that which he only vaguely feels and which he could *never represent in a true manner without the contact with visible reality and with the life which surrounds him*. It is precisely from this visible reality that he draws the objectivity which he needs in opposition to his personal subjectivity. It is precisely from this visible reality that he draws his means of expression: and, as regards the surrounding life, it is precisely this which has made his art non-figurative.

That which distinguishes him from the figurative artist is the fact that in his creations he frees himself from individual sentiments and from particular impressions which he receives from outside, and that he breaks loose from the domination of the individual inclination within him.

It is therefore equally wrong to think that the non-figurative artist creates through "the pure intention of his mechanical process," that he makes "calculated abstractions," and that he wishes to "suppress sentiment not only in himself but also in the spectator." It is a mistake to think that he retires completely into his system. That which is regarded as a system is nothing but constant obedience to the laws of pure plastics, to necessity, which art demands from him. It is thus clear that he has not become a mechanic, but that the progress of science, of technique, of machinery, of life as a whole, has only made him into a living machine, capable of realizing in a pure manner the essence of art. In this way, he is in his creation sufficiently neutral, that nothing of himself or outside of him can prevent him from establishing that which is universal. Certainly his art is art for art's sake . . . for the sake of the art *which is form and content at one and the same time.*

If all real art is "the sum total of emotions aroused by purely pictorial means" his art is the sum of the emotions aroused by plastic means.

It would be illogical to suppose that non-figurative art will remain stationary, for this art contains *a culture* of the use of new plastic means and their determinate relations. Because the field is new there is all the more to be done. What is certain is that no escape is possible for the non-figurative artist; he *must stay within his field and march toward the consequence of his art.*

This consequence brings us, in a future perhaps remote, toward the end of *art as a thing separated from our surrounding environment, which is the actual plastic reality.* But this end is at the same time a new beginning. Art will not only continue but will realize itself more and more. By the unification of architecture, sculpture, and painting, a new plastic reality will be created. Painting and sculpture will not manifest themselves as separate objects, nor as "mural art" which destroys architecture itself, nor as "applied" art, but *being purely constructive* will aid the creation of a surrounding not merely utilitarian or rational but also pure and complete in its beauty.

Beckmann
On My Painting

Max Beckmann (1884-1950), the great independent among German expressionists, did not attempt to explain his art, nor art in general. *On My Painting* is a beautiful extension in words of the haunting world of his paintings, one of the rare instances in which an artist has succeeded in putting into words the sense not just of his paintings, but of their genesis. It is probably more accurate to call it a prose poem, rather than an essay.

On My Painting was a lecture given by Beckmann at the New Burlington Galleries, London, in 1938. It was published in 1941 by the late Curt Valentin, in New York, and I am indebted to Ralph F. Colin, executor of the Valentin estate, for permission to use it here. Mrs. Max Beckmann, working from the original German manuscript, provided me with a number of corrections, especially in the "Song" toward the end of the text. With the greatest goodwill and patience, she checked and rechecked the revisions, and I offer her my sincerest thanks.

On My Painting

Before I begin to give you an explanation, an explanation which it is nearly impossible to give, I would like to emphasize that I have never been politically active in any way. I have only tried to realize my conception of the world as intensely as possible.

Painting is a very difficult thing. It absorbs the whole man, body and soul—thus I have passed blindly many things which belong to real and political life.

I assume, though, that there are two worlds: the world of spiritual life and the world of political reality. Both are manifestations of life which may sometimes coincide but are very different in principle. I must leave it to you to decide which is the more important.

What I want to show in my work is the idea which hides itself behind so-called reality. I am seeking for the bridge which leads from the visible to the invisible, like the famous cabalist who once said: "If you wish to get hold of the invisible you must penetrate as deeply as possible into the visible."

My aim is always to get hold of the magic of reality and to transfer this reality into painting—to make the invisible visible through reality. It may sound paradoxical, but it is, in fact, reality which forms the mystery of our existence.

What helps me most in this task is the penetration of space. Height, width, and depth are the three phenomena which I must transfer into one plane to form the abstract surface of the picture, and thus to protect myself from the infinity of space. My figures come and go, suggested by fortune or misfortune. I try to fix them divested of their apparent accidental quality.

One of my problems is to find the Self, which has only one form and is immortal—to find it in animals and men, in the heaven and in the hell which together form the world in which we live.

Space, and space again, is the infinite deity which surrounds us and in which we are ourselves contained.

That is what I try to express through painting, a function different from poetry and music but, for me, predestined necessity.

When spiritual, metaphysical, material, or immaterial events come into my life, I can only fix them by way of painting. It is not the subject which matters but the translation of the subject into the abstraction of the surface by means of painting. Therefore I hardly need to abstract things, for each object is unreal enough already, so unreal that I can only make it real by means of painting.

Often, very often, I am alone. My studio in Amsterdam, an enormous old tobacco storeroom, is again filled in my imagination with figures from the old days and from the new, like an ocean moved by storm and sun and always present in my thoughts.

Then shapes become beings and seem comprehensible to me in the great void and uncertainty of the space which I call God.

Sometimes I am helped by the constructive rhythm of the Cabala, when my thoughts wander over Oannes Dagon to the last days of drowned continents. Of the same substance are the streets with their men, women, and children; great ladies and whores; servant girls

and duchesses. I seem to meet them, like doubly significant dreams, in Samothrace and Piccadilly and Wall Street. They are Eros and the longing for oblivion.

All these things come to me in black and white like virtue and crime. Yes, black and white are the two elements which concern me. It is my fortune, or misfortune, that I can see neither all in black nor all in white. One vision alone would be much simpler and clearer, but then it would not exist. It is the dream of many to see only the white and truly beautiful, or the black, ugly and destructive. But I cannot help realizing both, for only in the two, only in black and in white, can I see God as a unity creating again and again a great and eternally changing terrestrial drama.

Thus without wanting it, I have advanced from principle to form, to transcendental ideas, a field which is not at all mine, but in spite of this I am not ashamed.

In my opinion all important things in art since Ur of the Chaldees, since Tel Halaf and Crete, have always originated from the deepest feeling about the mystery of Being. Self-realization is the urge of all objective spirits. It is this Self for which I am searching in my life and in my art.

Art is creative for the sake of realization, not for amusement; for transfiguration, not for the sake of play. It is the quest of our Self that drives us along the eternal and never-ending journey we must all make.

My form of expression is painting; there are, of course, other means to this end such as literature, philosophy, or music; but as a painter, cursed or blessed with a terrible and vital sensuousness, I must look for wisdom with my eyes. I repeat, with my eyes, for nothing could be more ridiculous or irrelevant than a "philosophical conception" painted purely intellectually without the terrible fury of the senses grasping each visible form of beauty and ugliness. If from those forms which I have found in the visible, literary subjects result—such as portraits, landscapes, or recognizable compositions—they have all originated from the senses, in this case from the eyes, and each intellectual subject has been transformed again into form, color, and space.

Everything intellectual and transcendent is joined together in painting by the uninterrupted labor of the eyes. Each shade of a flower, a face, a tree, a fruit, a sea, a mountain, is noted eagerly by the intensity of the senses to which is added, in a way of which I am not conscious, the work of my mind, and in the end the strength or weakness of *my soul*. It is this genuine, eternally un-

changing center of strength which makes mind and sense capable of expressing personal things. It is the strength of the soul which forces the mind to constant exercise to widen its conception of space.

Something of this is perhaps contained in my pictures.

Life is difficult, as perhaps everyone knows by now. It is to escape from these difficulties that I practice the pleasant profession of a painter. I admit that there are more lucrative ways of escaping the so-called difficulties of life, but I allow myself my own particular luxury, painting.

It is, of course, a luxury to create art and, on top of this, to insist on expressing one's own artistic opinion. Nothing is more luxurious than this. It is a game and a good game, at least for me; one of the few games which make life, difficult and depressing as it is sometimes, a little more interesting.

Love in an animal sense is an illness, but a necessity which one has to overcome. Politics is an odd game, not without danger I have been told, but certainly sometimes amusing. To eat and to drink are habits not to be despised but often connected with unfortunate consequences. To sail around the earth in 91 hours must be very strenuous, like racing in cars or splitting the atoms. But the most exhausting thing of all—is boredom.

So let me take part in your boredom and in your dreams while you take part in mine which may be yours as well.

To begin with, there has been enough talk about art. After all, it must always be unsatisfactory to try to express one's deeds in words. Still we shall go on and on, talking and painting and making music, boring ourselves, exciting ourselves, making war and peace as long as our strength of imagination lasts. Imagination is perhaps the most decisive characteristic of mankind. My dream is the imagination of space—to change the optical impression of the world of objects by a transcendental arithmetic progression of the inner being. That is the precept. In principle any alteration of the object is allowed which has a sufficiently strong creative power behind it. Whether such alteration causes excitement or boredom in the spectator is for you to decide.

The uniform application of a principle of form is what rules me in the imaginative alteration of an object. One thing is sure—we have to transform the three-dimensional world of objects into the two-dimensional world of the canvas.

If the canvas is only filled with a two-dimensional conception of space, we shall have applied art, or ornament. Certainly this may

give us pleasure, though I myself find it boring as it does not give
me enough visual sensation. To transform height, width, and depth
into two dimensions is for me an experience full of magic in which
I glimpse for a moment that fourth dimension which my whole
being is seeking.

I have always on principle been against the artist speaking about
himself or his work. Today neither vanity nor ambition causes me
to talk about matters which generally are not to be expressed even
to oneself. But the world is in such a catastrophic state, and art is
so bewildered, that I, who have lived the last thirty years almost as
a hermit, am forced to leave my snail's shell to express these few
ideas which, with much labor, I have come to understand in the
course of the years.

The greatest danger which threatens mankind is collectivism.
Everywhere attempts are being made to lower the happiness and the
way of living of mankind to the level of termites. I am against
these attempts with all the strength of my being.

The individual representation of the object, treated sympatheti-
cally or antipathetically, is highly necessary and is an enrichment
to the world of form. The elimination of the human relationship in
artistic representation causes the vacuum which makes all of us
suffer in various degrees—an individual alteration of the details of
the object represented is necessary in order to display on the canvas
the whole physical reality.

Human sympathy and understanding must be reinstated. There
are many ways and means to achieve this. Light serves me to a con-
siderable extent on the one hand to divide the surface of the canvas,
on the other to penetrate the object deeply.

As we still do not know what this Self really is, this Self in which
you and I in our various ways are expressed, we must peer deeper
and deeper into its discovery. For the Self is the great veiled mystery
of the world. Hume and Herbert Spencer studied its various con-
ceptions but were not able in the end to discover the truth. I believe
in it and in its eternal, immutable form. Its path is, in some strange
and peculiar manner, our path. And for this reason I am immersed
in the phenomenon of the Individual, the so-called whole Individ-
ual, and I try in every way to explain and present it. What are you?
What am I? Those are the questions that constantly persecute and
torment me and perhaps also play some part in my art.

Color, as the strange and magnificent expression of the inscru-
table spectrum of Eternity, is beautiful and important to me as a
painter; I use it to enrich the canvas and to probe more deeply into

the object. Color also decided, to a certain extent, my spiritual out-
look, but it is subordinated to light and, above all, to the treatment
of form. Too much emphasis on color at the expense of form and
space would make a double manifestation of itself on the canvas,
and this would verge on craft work. Pure colors and broken tones
must be used together, because they are the complements of each
other.

These, however, are all theories, and words are too insignificant
to define the problems of art. My first unformed impression, and
what I would like to achieve, I can perhaps only realize when I am
impelled as in a vision.

One of my figures, perhaps one from the "Temptation," sang
this strange song to me one night—

> Fill up again your pumpkins with alcohol, and
> hand up the largest of them to me. . . . Solemn, I
> will light the giant candles for you. Now in the
> night. In the deep black night.

> We are playing hide-and-seek, we are playing hide-
> and-seek across a thousand seas. We gods, we gods
> when the skies are red at dawn, at midday, and in
> the blackest night.

> You cannot see us, no you cannot see us but you are
> ourselves. . . . Therefore we laugh so gaily when
> the skies are red at dawn, at midday, and in the
> blackest night.

> Stars are our eyes and the nebulae our beards. . . .
> We have people's souls for our hearts. We hide
> ourselves and you cannot see us, which is just what
> we want when the skies are red at dawn, at midday,
> and in the blackest night.

> Our torches stretch away without end . . . silver,
> glowing red, purple, violet, green-blue, and black.
> We bear them in our dance over the seas and the
> mountains, across the boredom of life.

> We sleep and stars circle in the gloomy dream.
> We wake and the suns assemble for the dance across
> bankers and fools, whores and duchesses.

Thus the figure from my "Temptation" sang to me for a long time, trying to escape from the square on the hypotenuse in order to achieve a particular constellation of the Hebrides, to the Red Giants and the Central Sun.

And then I awoke and yet continued to dream . . . painting constantly appeared to me as the one and only possible achievement. I thought of my grand old friend Henri Rousseau, that Homer in the porter's lodge whose prehistoric dreams have sometimes brought me near the gods. I saluted him in my dream. Near him I saw William Blake, noble emanation of English genius. He waved friendly greetings to me like a super-terrestrial patriarch. "Have confidence in objects," he said, "do not let yourself be intimidated by the horror of the world. Everything is ordered and correct and must fulfil its destiny in order to attain perfection. Seek this path and you will attain from your own Self ever deeper perception of the eternal beauty of creation; you will attain increasing release from all that which now seems to you sad or terrible."

I awoke and found myself in Holland in the midst of a boundless world turmoil. But my belief in the final release and absolution of all things, whether they please or torment, was newly strengthened. Peacefully I laid my head among the pillows . . . to sleep, and dream, again.

Moore
On Sculpture
& Primitive Art

Henry Moore (born 1898) has long been a genial host to the inquiring visitor, whom he addresses with an almost pedagogical politeness and concern. One would assume that, accordingly, he would often write about his sculpture. The opposite is true, and these three little essays are among his rare writings; two of them, significantly, were lectures. "It is a mistake for a sculptor or a painter to speak or write very often about his job," he announces in *Notes on Sculpture,* but he admits that an artist can give his reader "clues." It is perhaps by keeping his mind on such clues that he succeeds in writing so directly, and in distilling so much in a few pages.

The Sculptor's Aims was first published in *Unit One,* 1934, edited by Herbert Read (London, Cassell and Company). *Notes on Sculpture* appeared first in *The Listener,* XVIII, 449 (August 18, 1937); *Primitive Art* was another *Listener* article, XXV, 641 (April 24, 1941). All three have frequently been republished together. I am grateful to Henry Moore for authorizing the inclusion of his essays in this anthology.

The Sculptor's Aims

Each sculptor through his past experience, through observation of natural laws, through criticism of his own work and other sculpture,

through his character and psychological make-up, and according to his stage of development, finds that certain qualities in sculpture become of fundamental importance to him. For me these qualities are:

Truth to material. Every material has its own individual qualities. It is only when the sculptor works direct, when there is an active relationship with his material, that the material can take its part in the shaping of an idea. Stone, for example, is hard and concentrated and should not be falsified to look like soft flesh—it should not be forced beyond its constructive build to a point of weakness. It should keep its hard tense stoniness.

Full three-dimensional realization. Complete sculptural expression is form in its full spatial reality.

Only to make relief shapes on the surface of the block is to forego the full power of expression of sculpture. When the sculptor understands his material, has a knowledge of its possibilities and its constructive build, it is possible to keep within its limitations and yet turn an inert block into a composition which has a full form existence, with masses of varied size and section conceived in their air-surrounded entirety, stressing and straining, thrusting and opposing each other in spatial relationship—being static, in the sense that the center of gravity lies within the base (and does not seem to be falling over or moving off its base)—and yet having an alert dynamic tension between its parts.

Sculpture fully in the round has no two points of view alike. The desire for form completely realized is connected with asymmetry. For a symmetrical mass being the same from both sides cannot have more than half the number of different points of view possessed by a non-symmetrical mass.

Asymmetry is connected also with the desire for the organic (which I have) rather than the geometric.

Organic forms, though they may be symmetrical in their main disposition, in their reaction to environment, growth, and gravity, lose their perfect symmetry.

Observation of natural objects. The observation of nature is part of an artist's life, it enlarges his form-knowledge, keeps him fresh and from working only by formula, and feeds inspiration.

The human figure is what interests me most deeply, but I have found principles of form and rhythm from the study of natural objects such as pebbles, rocks, bones, trees, plants, etc.

Pebbles and rocks show nature's way of working stone. Smooth,

sea-worn pebbles show the wearing away, rubbed treatment of stone and principles of asymmetry.

Rocks show the hacked, hewn treatment of stone, and have a jagged nervous block rhythm.

Bones have marvelous structural strength and hard tenseness of form, subtle transition of one shape into the next, and great variety in section.

Trees (tree trunks) show principles of growth and strength of joints, with easy passing of one section into the next. They give the ideal for wood sculpture, upward twisting movement.

Shells show nature's hard but hollow form (metal sculpture) and have a wonderful completeness of single shape.

There is in nature a limitless variety of shapes and rhythms (and the telescope and microscope have enlarged the field) from which the sculptor can enlarge his form-knowledge experience.

But beside formal qualities there are qualities of vision and expression:

Vision and expression. My aim in work is to combine as intensely as possible the abstract principles of sculpture along with the realization of my idea.

All art is an abstraction to some degree (in sculpture the material alone forces one away from pure representation and toward abstraction).

Abstract qualities of design are essential to the value of a work, but to me of equal importance is the psychological, human element. If both abstract and human elements are welded together in a work, it must have a fuller, deeper meaning.

Vitality and power of expression. For me a work must first have a vitality of its own. I do not mean a reflection of the vitality of life, of movement, physical action, frisking, dancing figures, and so on, but that a work can have in it a pent-up energy, an intense life of its own, independent of the object it may represent. When a work has this powerful vitality we do not connect the word Beauty with it.

Beauty, in the later Greek or Renaissance sense, is not the aim in my sculpture.

Between beauty of expression and power of expression there is a difference of function. The first aims at pleasing the senses, the second has a spiritual vitality which for me is more moving and goes deeper than the senses.

Because a work does not aim at reproducing natural appearances

it is not, therefore, an escape from life—but may be a penetration into reality, not a sedative or drug, not just the exercise of good taste, the provision of pleasant shapes and colors in a pleasing combination, not a decoration to life, but an expression of the significance of life, a stimulation to greater effort in living.

Notes on Sculpture

It is a mistake for a sculptor or a painter to speak or write very often about his job. It releases tension needed for his work. By trying to express his aims with rounded-off logical exactness, he can easily become a theorist whose actual work is only a caged-in exposition of conceptions evolved in terms of logic and words.

But though the non-logical, instinctive, subconscious part of the mind must play its part in his work, he also has a conscious mind which is not inactive. The artist works with a concentration of his whole personality, and the conscious part of it resolves conflicts, organizes memories, and prevents him from trying to walk in two directions at the same time.

It is likely, then, that a sculptor can give, from his own conscious experience, *clues* which will help others in their approach to sculpture, and this article tries to do this, and no more. It is not a general survey of sculpture, or of my own development, but a few notes on some of the problems that have concerned me from time to time.

Appreciation of sculpture depends upon the ability to respond to form in three dimensions. That is perhaps why sculpture has been described as the most difficult of all arts; certainly it is more difficult than the arts which involve appreciation of flat forms, shape in only two dimensions. Many more people are "form-blind" than color-blind. The child learning to see, first distinguishes only two-dimensional shape; it cannot judge distances, depths. Later, for its personal safety and practical needs, it has to develop (partly by means of touch) the ability to judge roughly three-dimensional distances. But having satisfied the requirements of practical necessity, most people go no farther. Though they may attain considerable accuracy in the perception of flat form, they do not make the further intellectual and emotional effort needed to comprehend form in its full spatial existence.

This is what the sculptor must do. He must strive continually to think of, and use, form in its full spatial completeness. He gets the solid shape, as it were, inside his head—he thinks of it, whatever its size, as if he were holding it completely enclosed in the hollow of his hand. He mentally visualizes a complex form *from all round itself;* he knows while he looks at one side what the other side is like; he identifies himself with its center of gravity, its mass, its weight; he realizes its volume, as the space that the shape displaces in the air.

And the sensitive observer of sculpture must also learn to feel shape simply as shape, not as description or reminiscence. He must, for example, perceive an egg as a simple single solid shape, quite apart from its significance as food, or from the literary idea that it will become a bird. And so with solids such as a shell, a nut, a plum, a pear, a tadpole, a mushroom, a mountain peak, a kidney, a carrot, a tree-trunk, a bird, a bud, a lark, a lady-bird, a bulrush, a bone. From these he can go on to appreciate more complex forms or combinations of several forms.

Since the Gothic, European sculpture had become overgrown with moss, weeds—all sorts of surface excrescences which completely concealed shape. It has been Brancusi's special mission to get rid of this overgrowth, and to make us once more shape-conscious. To do this he has had to concentrate on very simple direct shapes, to keep his sculpture, as it were, one-cylindered, to refine and polish a single shape to a degree almost too precious. Brancusi's work, apart from its individual value, has been of historical importance in the development of contemporary sculpture. But it may now be no longer necessary to close down and restrict sculpture to the single (static) form unit. We can now begin to open out. To relate and combine together several forms of varied sizes, sections, and directions into one organic whole.

Although it is the human figure which interests me most deeply, I have always paid great attention to natural forms, such as bones, shells, and pebbles, etc. Sometimes for several years running I have been to the same part of the seashore—but each year a new shape of pebble has caught my eye, which the year before, though it was there in hundreds, I never saw. Out of the millions of pebbles passed in walking along the shore, I choose out to see with excitement only those which fit in with my existing form-interest at the time. A different thing happens if I sit down and examine a handful

one by one. I may then extend my form-experience more, by giving my mind time to become conditioned to a new shape.

There are universal shapes to which everybody is subconsciously conditioned and to which they can respond if their conscious control does not shut them off.

Pebbles show nature's way of working stone. Some of the pebbles I pick up have holes right through them.

When first working direct in a hard and brittle material like stone, the lack of experience and great respect for the material, the fear of ill-treating it, too often result in relief surface carving, with no sculptural power.

But with more experience the completed work in stone can be kept within the limitations of its material, that is, not be weakened beyond its natural constructive build, and yet be turned from an inert mass into a composition which has a full form-existence, with masses of varied sizes and sections working together in spatial relationship.

A piece of stone can have a hole through it and not be weakened —if the hole is of a studied size, shape, and direction. On the principle of the arch, it can remain just as strong.

The first hole made through a piece of stone is a revelation.

The hole connects one side to the other, making it immediately more three-dimensional.

A hole can itself have as much shape-meaning as a solid mass.

Sculpture in air is possible, where the stone contains only the hole, which is the intended and considered form.

The mystery of the hole—the mysterious fascination of caves in hillsides and cliffs.

There is a right physical size for every idea.

Pieces of good stone have stood about my studio for long periods, because though I've had ideas which would fit their proportions and materials perfectly, their size was wrong.

There is a size to scale not to do with its actual physical size, its measurement in feet and inches—but connected with vision.

A carving might be several times over life size and yet be petty and small in feeling—and a small carving only a few inches in height can give the feeling of huge size and monumental grandeur, because the vision behind it is big. Example, Michelangelo's drawings or a Massacio madonna—and the Albert Memorial.

Yet actual physical size has an emotional meaning. We relate everything to our own size, and our emotional response to size is

controlled by the fact that men on the average are between five and six feet high.

An exact model, to one-tenth scale, of Stonehenge, where the stones would be less than us, would lose all its impressiveness.

Sculpture is more affected by actual size considerations than painting. A painting is isolated by a frame from its surroundings (unless it serves just a decorative purpose) and so retains more easily its own imaginary scale.

If practical considerations allowed me, cost of material, of transport, etc., I should like to work on large carvings more often than I do. The average in-between size does not disconnect an idea enough from prosaic everyday life. The very small or the very big takes on an added size emotion.

Recently I have been working in the country, where, carving in the open air, I find sculpture more natural than in a London studio, but it needs bigger dimensions. A large piece of stone or wood placed almost anywhere at random in a field, orchard, or garden, immediately looks right and inspiring.

My drawings are done mainly as a help toward making sculpture —as a means of generating ideas for sculpture, tapping oneself for the initial idea; and as a way of sorting out ideas and developing them.

Also, sculpture compared with drawing is a slow means of expression, and I find drawing a useful outlet for ideas which there is not time enough to realize as sculpture. And I use drawing as a method of study and observation of natural forms (drawings from life, drawings of bones, shells, etc.).

And I sometimes draw just for its own enjoyment.

Experience though has taught me that the difference there is between drawing and sculpture should not be forgotten. A sculptural idea which may be satisfactory as a drawing always needs some alteration when translated into sculpture.

At one time, whenever I made drawings for sculpture I tried to give them as much the illusion of real sculpture as I could—that is, I drew by the method of illusion, of light falling on a solid object. But I now find that carrying a drawing so far that it becomes a substitute for the sculpture either weakens the desire to do the sculpture, or is likely to make the sculpture only a dead realization of the drawing.

I now leave a wider latitude in the interpretation of the drawings I make for sculpture, and draw often in line and flat tones without

the light and shade illusion of three dimensions; but this does not mean that the vision behind the drawing is only two-dimensional.

The violent quarrel between the abstractionists and the surrealists seems to me quite unnecessary. All good art has contained both abstract and surrealist elements, just as it has contained both classical and romantic elements—order and surprise, intellect and imagination, conscious and unconscious. Both sides of the artist's personality must play their part. And I think the first inception of a painting or a sculpture may begin from either end. As far as my own experience is concerned, I sometimes begin a drawing with no preconceived problem to solve, with only the desire to use pencil on paper, and make lines, tones, and shapes with no conscious aim; but as my mind takes in what is so produced, a point arrives where some idea becomes conscious and crystallizes, and then a control and ordering begin to take place.

Or sometimes I start with a set subject; or to solve, in a block of stone of known dimensions, a sculptural problem I've given myself, and then consciously attempt to build an ordered relationship of forms, which shall express my idea. But if the work is to be more than just a sculptural exercise, unexplainable jumps in the process of thought occur; and the imagination plays its part.

It might seem from what I have said of shape and form that I regard them as ends in themselves. Far from it. I am very much aware that associational, psychological factors play a large part in sculpture. The meaning and significance of form itself probably depends on the countless associations of man's history. For example, rounded forms convey an idea of fruitfulness, maturity, probably because the earth, women's breasts, and most fruits are rounded, and these shapes are important because they have this background in our habits of perception. I think the humanist organic element will always be for me of fundamental importance in sculpture, giving sculpture its vitality. Each particular carving I make takes on in my mind a human, or occasionally animal, character and personality, and this personality controls its design and formal qualities, and makes me satisfied or dissatisfied with the work as it develops.

My own aim and direction seems to be consistent with these beliefs, though it does not depend upon them. My sculpture is becoming less representational, less an outward visual copy, and so what some people would call more abstract; but only because I

believe that in this way I can present the human psychological
content of my work with the greatest directness and intensity.

Primitive Art

The term *Primitive Art* is generally used to include the products
of a great variety of races and periods in history, many different
social and religious systems. In its widest sense it seems to cover
most of those cultures which are outside European and the great
Oriental civilizations. This is the sense in which I shall use it here,
though I do not much like the application of the word "primitive"
to art, since, through its associations, it suggests to many people
an idea of crudeness and incompetence, ignorant gropings rather
than finished achievements. Primitive art means far more than that;
it makes a straightforward statement, its primary concern is with
the elemental, and its simplicity comes from direct and strong feel-
ings, which is a very different thing from that fashionable simplicity-
for-its-own-sake which is emptiness. Like beauty, true simplicity is
an unselfconscious virtue; it comes by the way and can never be
an end in itself.

The most striking quality common to all primitive art is its
intense vitality. It is something made by people with a direct and
immediate response to life. Sculpture and painting for them was
not an activity of calculation or academism, but a channel for ex-
pressing powerful beliefs, hopes, and fears. It is art before it got
smothered in trimmings and surface decorations, before inspiration
had flagged into technical tricks and intellectual conceits. But apart
from its own enduring value, a knowledge of it conditions a fuller
and truer appreciation of the later developments of the so-called
great periods, and shows art to be a universal continuous activity
with no separation between past and present.

All art has its roots in the "primitive," or else it becomes deca-
dent, which explains why the "great" periods, Pericles' Greece and
the Renaissance for example, flower and follow quickly on primitive
periods, and then slowly fade out. The fundamental sculptural
principles of the Archaic Greeks were near enough to Phidias' day
to carry through into his carvings a true quality, although his con-
scious aim was so naturalistic; and the tradition of early Italian
art was sufficiently in the blood of Massacio for him to strive for
realism and yet retain a primitive grandeur and simplicity. The
steadily growing appreciation of primitive art among artists and

the public today is therefore a very hopeful and important sign.

Excepting some collections of primitive art in France, Italy, and Spain, my own knowledge of it has come entirely from continual visits to the British Museum during the past twenty years. Now that the Museum has been closed [during World War II], one realizes all the more clearly what one has temporarily lost—the richness and comprehensiveness of its collection of past art, particularly of primitive sculpture, and perhaps by taking a memory-journey through a few of the Museum's galleries I can explain what I believe to be the great significance of primitive periods.

At first my visits were mainly and naturally to the Egyptian galleries, for the monumental impressiveness of Egyptian sculpture was nearest to the familiar Greek and Renaissance ideals one had been born to. After a time, however, the appeal of these galleries lessened; excepting the earlier dynasties. I felt that much of Egyptian sculpture was too stylized and hieratic, with a tendency in its later periods to academic obviousness and a rather stupid love of the colossal.

The galleries running alongside the Egyptian contained the Assyrian reliefs—journalistic commentaries and records of royal lion hunts and battles, but beyond was the Archaic Greek room with its lifesize female figures, seated in easy, still naturalness, grand and full like Handel's music; and then near them, downstairs in the badly lit basement, were the magnificent Etruscan Sarcophagus figures—which, when the Museum reopens, should certainly be better shown.

At the end of the upstairs Egyptian galleries were the Sumerian sculptures, some with a contained bull-like grandeur and held-in energy, very different from the liveliness of much of the early Greek and Etruscan art in the terracotta and vase rooms. In the prehistoric and Stone Age room an iron staircase led to gallery wall-cases where there were originals and casts of Paleolithic sculptures made 20,000 years ago—a lovely tender carving of a girl's head, no bigger than one's thumbnail, and beside it female figures of very human but not copyist realism with a full richness of form, in great contrast with the more symbolic two-dimensional and inventive designs of Neolithic art.

And eventually to the Ethnographical room, which contained an inexhaustible wealth and variety of sculptural achievement (Negro, Oceanic Islands, and North and South America), but overcrowded and jumbled together like junk in a marine store, so that after hundreds of visits I would still find carvings I had not discovered

there before. Negro art formed one of the largest sections of the room. Except for the Benin bronzes it was mostly woodcarving. One of the first principles of art so clearly seen in primitive work is truth to material; the artist shows an instinctive understanding of his material, its right use and possibilities. Wood has a stringy fibrous consistency and can be carved into thin forms without breaking, and the Negro sculptor was able to free arms from the body, to have a space between the legs, and to give his figures long necks when he wished. This completer realization of the component parts of the figure gives to Negro carving a more three-dimensional quality than many primitive periods where stone is the main material used. For the Negro, as for other primitive peoples, sex and religion were the two main interacting springs of life. Much Negro carving, like modern Negro spirituals but without their sentimentality, has pathos, a static patience and resignation to unknown mysterious powers; it is religious and, in movement, upward and vertical like the tree it was made from, but in its heavy bent legs is rooted in the earth.

Of works from the Americas, Mexican art was exceptionally well represented in the Museum. Mexican sculpture, as soon as I found it, seemed to me true and right, perhaps because I at once hit on similarities in it with some eleventh-century carvings I had seen as a boy on Yorkshire churches. Its "stoniness," by which I mean its truth to material, its tremendous power without loss of sensitiveness, its astonishing variety and fertility of form-invention, and its approach to a full three-dimensional conception of form, make it unsurpassed in my opinion by any other period of stone sculpture.

The many islands of the Oceanic groups all produced their schools of sculpture with big differences in form-vision. New Guinea carvings, with drawn out spider-like extensions and bird-beak elongations, made a direct contrast with the featureless heads and plain surfaces of the Nukuoro carvings; or the stolid stone figures of the Marquesas Islands against the emasculated ribbed wooden figures of Easter Island. Comparing Oceanic art generally with Negro art, it has a livelier thin flicker, but much of it is more two-dimensional and concerned with pattern making. Yet the carvings of New Ireland have, besides their vicious kind of vitality, a unique spatial sense, a bird-in-a-cage form.

But underlying these individual characteristics, these featural peculiarities in the primitive schools, a common world-language of form is apparent in them all; through the working of instinctive sculptural sensibility, the same shapes and form relation-

ships are used to express similar ideas at widely different places and periods in history, so that the same form-vision may be seen in a Negro and a Viking carving, a Cycladic stone figure and a Nukuoro wooden statuette. And on further familiarity with the British Museum's whole collection it eventually became clear to me that the realistic ideal of physical beauty in art which sprang from fifth-century Greece was only a digression from the main world tradition of sculpture, whilst, for instance, our own equally European Romanesque and Early Gothic are in the main line.

Primitive art is a mine of information for the historian and the anthropologist, but to understand and appreciate it, it is more important to look at it than to learn the history of primitive peoples, their religions and social customs. Some such knowledge may be useful and help us to look more sympathetically, and the interesting titbits of information on the labels attached to the carving in the Museum can serve a useful purpose by giving the mind a needful rest from the concentration of intense looking. But all that is really needed is response to the carvings themselves, which have a constant life of their own, independent of whenever and however they came to be made, and they remain as full of sculptural meaning today to those open and sensitive enough to perceive it as on the day they were finished.

Robert L. Herbert received his B.A. from Wesleyan University; his M.A. and Ph.D. from Yale University, where he is now Associate Professor of the History of Art. He is the author of *Barbizon Revisited* and *Seurat's Drawings* and the editor of *The Art Criticism of John Ruskin*. He has organized several art exhibitions, especially of the Barbizon School, and has contributed many articles to leading journals of art and art history.